GraphicDesign/Seattle

GraphicDesign/Seattle

Watkins College
of Art & Design

WORDS BY JOHN KOVAL

Documentary Book Publishers
Seattle, Washington

Graphic Design / Seattle

Copyright © 1996 Documentary Book Publishers Corporation

First edition 1996

For information, write Documentary Book Publishers, Suite 260, 615 2nd Avenue, Seattle, Washington 98104

Produced by Marquand Books, Inc., Seattle

Designed by Noreen Ryan and Brian Ellis Martin

Cover design by John Hubbard

Cover photograph by Marco Prozzo

Back cover photograph by Kristi Palmer

Photographs on the title page, page 6, and page 8 are © Tony Stone Images, Inc.

Text by John Koval

Publisher: Barry Provorse

Pre-press by Color Service Inc., Seattle, Washington

Printed by Grossberg Tyler Lithographers, Seattle, Washington

Library of Congress Catalog Card Number 96-086094

ISBN 0-935503-18-8

Contents

Foreword

In some respects you could say I got my start in Seattle. My parents met at the Cornish Institute. My father worked as an art director in Seattle until he and my mother moved to the San Francisco Bay Area where they raised me and *CA* magazine. My own love affair with Seattle really began in the 1980s when we printed *Communication Arts* at Craftsman Press. Few cities still look attractive after several all-night press checks, but Seattle does. There is so much going on: art, music, fashion, technology, coffee. The energy is infectious. As an outside observer, it's no surprise that Seattle has become such a design mecca. The place exudes creativity. The Seattle design community's rise to national prominence is a direct result of the nurturing environment, a rich and varied culture, a supportive camaraderie in the creative community and an open-minded business environment. The fact that Seattle is also one of the most beautiful cities in the world didn't hurt either.

PATRICK COYNE
Editor/Designer
Communication Arts

Introduction

Seattle Design

In 1995, the American Institute of Graphic Arts (AIGA), the largest association of graphic designers on the continent, selected Seattle for their biennial national convention.

The membership did not choose the site for the weather. They chose Seattle because of the climate: graphic designers in this city are a hot national topic.

The local AIGA chapter has 420 members, making it the fifth largest chapter in the United States. Work by local designers appears regularly in leading industry publications such as *Communication Arts* and *Graphis*. And local client rosters that include Microsoft, Boeing, Starbucks and Kenworth earn the envy of graphic design firms around the country.

Why did Seattle achieve this position? Two reasons, really. One is that the graphic design industry has experienced considerable growth in general. The other relates directly to the talent and passion of the designers who have grown up or gravitated here.

Seattle's Ted Leonhardt has a compelling theory which explains why graphic design has taken an influential, if not primary, role in marketing communications across all business strata. "Marketers," says Leonhardt, "have moved from mass communications to targeted communications."

From the 1940s on, American companies concentrated on "marketing to the averages," Leonhardt explains. "Historically, those were shortage-driven times. All a brand had to say to a consumer was, 'Here I am!' Today, in our extremely competitive, surplus-driven environment, a brand must market to the differences."

In the past, a company would hand over their entire advertising budget to one ad agency. But businesses today are split into individual product and service groups, each with their own, smaller budget, and each with a particular marketing objective.

This segmenting of communication needs and the attending requirements for targeted marketing materials opened the door for design firms and diminished the involvement of the mass communication experts, the ad agencies.

It also prompted graphic design firms to stress "strategic design," a term popularized by the internationally known, San Francisco–based Landor Associates, and adopted almost universally by designers today. Like ad agencies, design firms now begin working from "communication platforms" and create tactics for "meeting marketing objectives."

Gone are the days when corporate brochures were simply glorified business cards.

THE ORIGINS OF GRAPHIC DESIGN IN SEATTLE

Forty years ago, there was no listing for "graphic designers" in the Seattle Yellow Pages. In 1995, there were 338. Where did they come from?

In the 1960s, many came from local design schools.

The Burnley School of Professional Art was founded in 1946 and became the Art Institute of Seattle in 1982. In the intervening years, it progressed from a fine art school into a commercial talent foundry under the auspices of Jess and Colleen Cauthorn, who purchased the school in the late 1950s.

In the 1960s Burnley offered graphic design classes. Local design luminaries such as Rick Becker, Ted Leonhardt and Kathy Spangler came out of Burnley.

Another Seattle institution, the internationally respected Cornish College of the Arts, helped launched the careers of many talented professionals such as Leslie Phinney, Bob Grindeland and Janet DeDonato.

Cornish was offering graphic design classes by the time the school received full accreditation in 1976. It wasn't until 1986 that two separate departments were formalized for graphic design and illustration. But the school maintains the importance of each discipline: illustrators must take graphic design courses, and vice versa.

One clear date for the insertion of the term "graphic design" into the local everyday lexicon is 1965. As Professor Dick Dahn remembers, that was the year he arrived at the University of Washington to teach. "On my first day," says Dahn, "I saw a sign painter working on the door to my classroom, replacing the words 'Commercial Art' with 'Graphic Design.'"

As the sun comes up later in the West, Eastern universities were ahead in the nomenclature game: Dahn received his degree in graphic design from Yale in 1959. "I first went to work at R.R. Donnelly in Chicago," he remembers. "There a veteran prepress man approached me and said, 'So you're a graphic designer.' I nodded. 'So as I understand it,' he told me, 'that means you're a slow layout man.'"

It's clear that, by the mid-1960s, graphic designers were graduating from Seattle schools.

But before that, those who would eventually become the graphic designers of today were working and studying in other disciplines.

As we shall see, graphic design was born of three mothers: industrial design, commercial art and fine art.

1941–1945: INDUSTRIAL DESIGNERS & THE WAR BOOM

Wartime procurement stimulated the Seattle economy as no other event had since the Klondike Gold Rush of 1897 and the ship-building boom of 1917, which employed 50,000. In 1942, President Roosevelt promised that the country would build 50,000 warplanes a year. As Roger Sale pointed out in *Seattle Past to Present,* this number "was more than had ever been built in the entire history of aviation."

By 1944, Boeing employment passed 50,000. In 1968 that number would surpass 104,000, an all-time high for any Pacific Northwest company.

Aerospace engineers did a remarkable job of making airplanes fly faster and more efficiently. But to make the airplanes commercially desirable, Boeing needed industrial

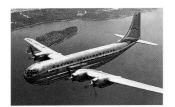

Industrial designers helped shape the double-decker Stratocruiser, which Boeing rolled out in 1947.

designers. By designing human interfaces between the passengers and the planes, industrial designers were charged with making sure flying was as pleasant an experience as it could be.

Boeing enlisted the talent at Walter Dorwin Teague, one of the oldest and still one of the largest industrial design firms in America. This world-class design firm maintains an office in the area today.

The firm's Frank DeGudice helped fashion the interior of the famous, double-decker Stratocruiser in 1946. Other Teague designers have helped create the airplane seats we sit in today, including those in the new 777.

The designers at Teague worked on more than airplanes locally. They blueprinted a method of making doors for the building product division of the Northwest giant, Simpson Timber Company. They created an ingenious method of using interchangeable parts to manufacture the doors, a technique that is still in use today.

There was also a smattering of local industrial designers, the most famous of whom was Gideon Kramer, designer of the "Stratos" chair for the top of the Space Needle in 1962.

For industrial designers, graphic design was just one of the many projects they accepted. In the main, they preferred the catch-all title, "designer."

However, there were many marketing professionals during this time who specialized in lettering, logos, layouts and other forms of graphic design. They called themselves commercial artists.

In the 1950s most of them worked in, or for, advertising agencies.

THE 1950S: WHEN AD AGENCIES RULED

When there was no such thing as a graphic designer, agency art directors commissioned commercial artists for lettering, layouts or logos. The working relationships among them had their ups and downs.

In 1949, the Seattle Art Directors Society was formed. It included both agency art directors and the freelance commercial artists they employed. As membership grew, surveys on pricing became part of the regular agenda, and friendly conflicts soon developed between art directors and freelancers.

Consequently, the largest art studio in the Northwest at the time, Studio Art, began getting together informally with another major studio, Harry Bonath and Associates. Together they ended the ad agency policy of demanding speculative art and paying for it only if it was used.

Spurred by success, the artists formed another professional organization in 1955 called Art Studio Association of Seattle. It became the Society of Professional Graphic Artists (SPGA) in 1975. Founding members included Bill Werrbach, Bob Wandesford, Rudy Bundas, Ray Gerring and Harry Bonath.

The group concentrated on ethics and fair business practices. One of its most noteworthy achievements was to convince the State of Washington in 1967 that the work of artists should no longer be subject to sales tax.

Where the SPGA supported the industry in general, another group of commercial artists got together strictly

Many commercial artists worked in-house for Frederick & Nelson, once Seattle's predominant department store.

for their own business reasons. In 1958, they formed Graphic Studios, a collaboration that flourished for 27 years.

As charter member Mits Katayama explains, "We were a group of seven artists, all with our own specialties, sharing a common office space." Even then, Katayama admits, "it was considered hip to go out of town and hire New York or other big city artists for big jobs."

It was that kind of thinking that rattled David Strong, considered by some to be the father of Seattle's graphic design scene.

"I might have been the first person in town to put 'Graphic Design' on my business card," says Strong. "Of course, I also had to put 'Commercial Art' or no one would know what I was talking about."

Bob Matheison and O. K. Devin were other professionals who called themselves "designers" quite early on in the game, but Strong had his cards when he graduated from the University of Washington in 1958.

"Two things happened when I graduated," says Strong. "I got hold of Paul Rand's Graphic Standards Manual for Westinghouse and said, 'This is what we should be doing here.' Then I found out that Weyerhaeuser went out of town and hired Lippincott & Marguilis to do their new corporate identity in 1957. I resolved to build a local firm that would get that kind of business in the future."

Strong actually did win the job to create Weyerhaeuser's Graphic Standards Manual in 1966. But before that, he got experience and exposure, as many did, with the 1962 Seattle World's Fair.

1962: WORLD'S FAIR EXPOSURE

"When the World's Fair opened," Strong reminisces, "the shops beneath the grandstand of Memorial Stadium were getting no traffic whatsoever. The problem was that people who entered the fair could not see the retail entrance since it was below grade and behind a fence. Most people walked in and immediately headed for the Space Needle.

"My solution was simply to paint huge orange, purple and yellow arrows on the building pointing to the entrance. Traffic improved instantly." When notorious architect Philip Johnson visited the fair, he said that those arrows were the best graphics he saw, and years later, much to Strong's delight, "a writer in one of the trade magazines called me the originator of 'supergraphics,' which may have in fact been true."

Strong puts forth the theory that, because the fair included exhibits created by world-famous designers, the local business community became much more aware of the level of sophistication in design.

The theme of the Seattle World's Fair was "Century 21." Here, as in the rest of America, people were looking ahead to what the future would bring.

1968: ATTRACTING NATIONAL BUSINESS

From the late 1960s into the early 1980s, The David Strong Design Group was the most dominant graphic design firm

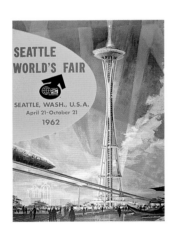

The World's Fair gave local graphic designers a chance to create brochures, signage and posters such as this one.

in the city. Several local luminaries once worked for Strong, including John Hornall (now of Hornall Anderson Design Works), Gary LaComa (once of Hunter Tavenor LaComa, now with TeamDesign) and John Van Dyke.

One of Seattle's current international stars, Van Dyke has always shared Strong's passion: "When I started, I saw that the most important jobs always went to firms out of town. I was determined not only to change that, but also to start bringing in business from other cities to Seattle."

How would Van Dyke accomplish that? "The quality of the work," he says. "That's paramount. Like many other local designers, I was always driven to do work that stood above any other in the country."

In the early 1970s, there wasn't much business in Seattle anyway. Boeing slumped dramatically, real estate prices fell and a billboard appeared on the outskirts of town that read, "Will the last person who leaves Seattle please turn out the lights?"

However, like any city built by pioneers, it wouldn't take long for Seattle to bounce back.

THE 1970S: GET OUT OF TOWN
Before Seattle became the mecca of Grunge music in the 1980s, young musicians were counseled to leave town if they wanted to succeed. "Go to L.A., San Francisco, Chicago or New York," they would be told by mentors. "Seattle isn't the place to get started. There are no opportunities."

Talented young designers were given the same advice.

The attitude was turned into a city motto: "Seattle: If you can make it there, so what?"

EMERGING NEW OPPORTUNITIES: ART REPS
Nonetheless, it was hard to leave the scenery and the lifestyle, so many young designers stayed, dug in, and set about building reputations for excellent work.

As it turned out, opportunities did appear. One of them took the form of a service business called "Artist Representation." And one of the early Seattle pioneers in this industry was Pat Hackett.

In 1975, Hackett started gathering artists and representing them from an unheated storefront in Belltown, an area off the downtown core popular with the city's transient population.

The client advantages of using an art rep were better quality control, more stable pricing, less risk and more choices. Instead of searching for and negotiating with several different artists, a designer could contact an art rep and see a wide range of work at once.

But it took Hackett a while to persuade art buyers of these benefits. She had to supplement her income by doing fashion modeling. Today she represents nearly 30 commercial artists.

Other artist representatives followed her lead, including Sharon Dodge, Jerry Jaz, Donna Jorgenson, Susan Trimpe and Kolea Baker.

Kolea, a former art director, started her art rep business in 1985 because of a passion for fine art. Throughout her

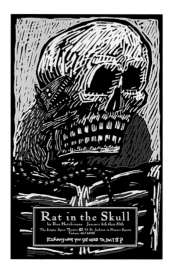

Art Chantry's posters have been exhibited on telephone poles and in art musuems in Tokyo, Moscow and Warsaw.

The 12 x 12 Art Auction was just one way that the Seattle Design Association helped designers socialize regularly.

career she has deliberately limited the size of her stable to around 10 talented artists and photographers. "I need to be closely connected to my artists in order to ensure consistent quality," she says. "That takes time, and there's only so much time in a day."

Today Kolea's firm serves thousands of clients across North America, in the Far East and in Europe.

Did you notice that, of the six art reps mentioned, five were women?

1977: SEATTLE WOMEN IN DESIGN

In the same year President Carter pardoned Vietnam war draft evaders and the National Women's Conference was held in Houston, Texas, a group of women graphic designers organized Seattle Women in Design.

Ellen Ziegler got the idea at the 1977 Aspen Design Conference. "Some of us noticed that the number of women speaking at the conference—one—was a poor representation considering that half the attendees were women."

Ziegler found designers who shared her enthusiasm, including Leah Hall, Pat Hansen, Sue Cummings, Anne Traver, Kathryn Spangler and Gretchen Rhode. Other early members included Pat Hackett, Paula Rees, Carole Jones and Leslie Phinney.

As Leah Hall remembers, "There were about 14 of us sitting around on the living room floor of someone's house, talking about what our purpose would be."

In the early days, the purpose was to create solidarity among women designers and serve as a counterpoint to the traditionally male- and advertising-dominated Art Director's Club.

Hall was serving as president in 1983 when the organization changed its name to the Seattle Design Association (SDA). "It seemed that the support and promotion of design in general had become more important than the women issue."

The SDA remained a dynamic force for many years, sponsoring student internships, a local design awards show and the immensely popular 12 x 12 Auction, which sold works by fine artists exactly one foot square at a biennial gala event. Half the proceeds went to the artist, the other half supported SDA programs.

There has always been a thin line between fine art and graphic design.

1978: FINE ART INFLUENCES

Many of Seattle's graphic designers began with a fine art background. Art Chantry, who graduated with a degree in painting in 1978, became a designer by default. "By chance, I came across an article on Polish posters in an old *Graphis*," Chantry says. "I quickly realized that this was graphic design—and that's what I was doing."

Warren Wilkins is another local designer with an art background. He and Tommer Peterson formed What It Is: Studios with artist Jack Mackie in 1978. They adopted a prophetic tag line: "A Sufficiently Advanced Technology Is Indistinguishable from Magic," a rewording of a statement by science-fiction writer Arthur C. Clarke.

What It Is: Studios epitomized the loose, fun style of late 1960s and early 1970s hippie art. The three men had a great time creating posters for arts organizations, putting on wild and memorable parties and doing "arty" projects connected with promotions.

When Wilkins "got tired of looking out the window on Saturday nights and thinking, 'If I only had 20 bucks . . .'" he went to work briefly for a graphic design firm run by Kathy Spangler, Ted Leonhardt and John Hornall.

Shortly afterward, he rejoined Peterson. Until they finally broke up in 1993 to pursue different interests, Wilkins and Peterson became the longest-lasting design partnership in Seattle. Today Hornall Anderson holds that distinction.

In the late 1970s, more and more artistically inclined young people in Seattle were discovering a way to pursue their creative desires and, at the same time, have a few bucks to spend on Saturday night.

THE 1980S: BUSINESS BOOMS IN SEATTLE

Nordstrom, the city's classic clothing retailer, began an aggressive expansion program, first in California and then throughout the U.S. Starbucks redefined coffee, and Red Hook started the mircobrew craze. Nintendo picked up the TV game market after Atari failed to capitalize on "Pong." Alaska Airlines used Joel Sedelmeier TV commercials to solidify its marketing position as "The World's Last Great Airline." And Microsoft established a dominance that has only strengthened over time.

If you held stock in some of these companies early on, you are probably reading this on your yacht in the South Seas.

The success of these enterprises, and others which sprang up or moved here to service them, fattened the portfolios of local design firms. The original Starbucks logo was modernized in 1971 by Terry Heckler, a brilliant designer responsible for the early Rainier Beer TV commercials.

Tim Girvin returned from studying design in Europe on a National Endowment for the Arts grant to open his studio in 1977. He developed exquisite calligraphy for Nordstrom's seasonal promotions and immediately began appearing in award books.

Film director Francis Ford Coppola saw Girvin's work in one of these books and hired him to work on the logo for *Apocalypse Now.* The fame he earned was an entree into Hollywood, and Girvin's firm has since created literally hundreds of movie logotypes for major studios.

In 1985, John Hornall and Jack Anderson began creating spectacular, award-winning graphics for K2 Skis that helped develop a solid international reputation for the manufacturer. Because their design firm has a policy of supporting their recommendations by showing all iterations created for a project, Hornall Anderson Design Works has, over the years, presented hundreds of design ideas to K2. The partnership continues to this day.

However, in the early 1980s, few Seattle designers enjoyed a national reputation.

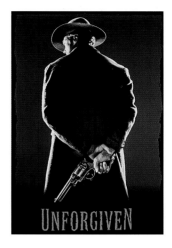

Tim Girvin Design created this striking poster and logotype for Clint Eastwood's Academy Award–winning film.

Hornall Anderson Design Works helped K2 Skis grow internationally with attention-getting graphics.

STREET-LEVEL DESIGN: A LOCAL BAD BOY

In 1984, a writer at an industry conference in Sacramento collared a celebrated San Francisco designer and said, "I'm from Seattle. What do you know about Seattle?" He answered without hesitation: "Art Chantry."

One of Chantry's more memorable public stances is his insistence that graphic designers are nothing more than "corporate whores."

An iconoclast and self-proclaimed "folk artist for a merchant/technical culture," Chantry recalls that he made his first posters at the age of 15 for a guitar repair shop. The Seattle Art Museum (SAM) showed a retrospective of his posters in 1993, finally giving recognition to a local designer whose work had already been hung in galleries and museums in, among other places, Tokyo, Warsaw and Moscow.

In the show's program notes, SAM curator Patterson Sims said that Art Chantry "is a figure of semi-legendary status in a city that had developed a national reputation for . . . spirited, savvy designers."

True enough in 1993. But back in the early 1980s, Chantry was the first and only Seattle name the writer could get out of that San Francisco designer.

That would change soon enough.

SEATTLE: AMERICA'S MOST LIVABLE CITY

Word about Seattle's "quality of life" was reinforced in 1989 when *Money* magazine ranked Seattle number one on its annual list of "Most Livable Cities."

During the 1980s, the influx of immigrants doubled real estate prices in and around the city. And more companies arose: more coffee and beer companies, more software companies, more sportswear companies and more professional services companies to support them all.

Commercial and residential real estate companies generated a frenzy of building. These new structures required a mass of logomarks, environmental graphics and business communication materials. These included leasing brochures to appeal to tenants. The developers themselves needed capabilities brochures targeted to financial lenders and development partners.

Ad agencies were still soliciting mass media work at this time, which paid more handsomely than brochures, so design firms easily won this new business.

Prominent local designer Paula Rees, who moved up from Portland in 1979 at the suggestion of David Strong, established her environmental graphics expertise at this time with her architect husband, Jeff Thompson. Rees helped create City Center, the exciting retail component of a downtown Seattle highrise finished in 1988, which drew tenants such as Barney's New York and Benetton. Rees would later become national president of the Society for Environmental Graphic Design (SEGD).

Seattle's newfound cachet attracted many supremely gifted designers, photographers and commercial artists who were plagued by taxes in California, sick of the cacophony of New York streets and driven away by depressed economic conditions in Texas and the Northeast's "Rust Belt."

Established local design firms were inundated with resumes and had their pick of talent. Many individuals arrived and opened their own shops, including David Betz, who worked for Michael Vanderbyl in San Francisco, and Ken Shafer, who was at Woody Pirtle's firm in Dallas.

At the same time, the area's design schools such as Cornish, the University of Washington, the Art Institute and the New School of Visual Concepts turned out promising designers who would soon establish solid reputations for excellent creative work.

Seattle was awash with design talent.

EVOLUTION: SOPHISTICATED DESIGN TOOLS

When local software developer Paul Brainerd invented the term "Desktop Publishing" and supported it with brilliant programs from his firm, Aldus, graphic design entered a new era.

Bob Grindeland, now of TeamDesign, remembers how these tools changed his life. "I was working with a designer named David Imanaka in 1983 when he brought in a beta test of the PageMaker software. He showed me how to run it on a MAC 512, a dinosaur of a computer that didn't even have a hard drive. I was so intrigued, I ran out and bought an Apple Macintosh myself."

Adobe Illustrator appeared the next year, then Freehand and PhotoShop, and suddenly techniques such as typesetting, manipulating photos, changing layouts and "tweaking" illustrations now could be done more speedily and at a lower cost than before.

Grindeland was one of the first to enter the digital arena and reflects on how "there were few people to talk to about these developments in the mid-1980s." He relied on magazines and national connections to share information and experiences. "Of course, the number of digital designers grew and grew."

To say that computer technology completely and irrevocably changed the way graphic design firms operate is a serious understatement.

For instance, in the mid-1980s, you were looking at hundreds if not thousands of dollars if you wanted to drop a rendering into a skyline photo to show what a highrise would look like when completed. In the mid-1990s, a proficient digital designer could accomplish this on a desktop computer in a matter of minutes.

Then, you needed stats and a darkroom for an enlarger as big as a Volkswagen. Now, all you need is a laptop and a scanner.

Then, and now, technological advancements have design firms scrambling to keep up with the competition. The race belongs to the swift.

1986: THE AMERICAN INSTITUTE OF GRAPHIC ARTS

The AIGA, founded in 1914, is a national non-profit organization that works to advance excellence in graphic design as a discipline, and as a professional and cultural force. With 37 chapters in cities all across the country, the AIGA sponsors competitions, exhibitions, publications, professional seminars and educational activities.

Pat Hansen, who was a founding officer of Seattle

Led by Pat Hansen, local designers formed the Seattle Chapter of the American Institute of Graphic Arts in 1986.

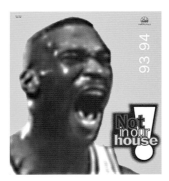

Werkhaus Design earned national attention with this extremely popular poster for the NBA's Seattle Supersonics.

The NFL selected Seattle's Ken Shafer to design the logo for the Pro Football Hall of Fame in Canton, Ohio.

Women in Design in 1977, stepped to the front again in 1986 and became founding president of AIGA/Seattle.

Membership swelled every year, and now AIGA/Seattle is one of the organization's largest and most energetic chapters. Former chapter presidents such as Hansen and Janet DeDonato have been appointed to the 12-person national board, representing Seattle in AIGA's New York headquarters.

Over the years, selfless volunteers serving on the Seattle board of directors developed programs and sponsored events that attracted national attention. For instance, AIGA/Seattle pioneered the formation of student chapters which brought tyro designers into the organization for lower fees. In the early 1990s, students from different schools designed a modest monthly newsletter for the Seattle membership.

AIGA/Seattle also organized a competition called the "Trapeze Awards." Students from art schools and universities throughout Washington submitted work, and up to six winners were awarded six-week internships with local design firms.

This proved to be a smart move. In order to compete, and even survive, it was essential that existing design firms attract talented digital designers coming out of the schools.

THE EARLY 1990S: AMERICA'S MOST LOVABLE DESIGNERS

This era saw the formation of hot, young "alternative" design shops such as Modern Dog, Burning Bush and especially Werkhaus, whose "Not in My House" poster for the NBA's Seattle Supersonics would become a collector's item. When Werkhaus accepted major projects from a national beer company, they were added to the growing list of local firms who were bringing in business from outside the region.

Revered local firms such as annual report specialists Leimer Cross and American entertainment industry favorite Tim Girvin Design continued to collect awards and prestigious national accounts. Recent arrival Ken Shafer Design was commissioned to create the identity for the NFL's Hall of Fame, Image Ink did work for Taco Time, Ilium brought in major signage business from the City of Los Angeles, Hansen Design Company was commissioned to do a worldwide visual communications review for Apple Computer, Daigle Design created brochures for Porsche, the Z Group pulled in projects from AT&T, Edquist Design won the Hawaii Children's Discovery Center project, TeamDesign created multimedia for Oracle and Hornall Anderson Design Works continued to beat out design firms in New York for business.

On the national design scene, Seattle had arrived.

CHALLENGES: SERVING CLIENTS ELSEWHERE

How do Seattle design firms deal with the logistics of making themselves available to clients in other parts of the country? It's a good question. Kerry Leimer has a good answer.

"Design is first and foremost a service business," says Leimer. "It doesn't matter where you are as long as the client feels that you can give them whatever they want, whenever they want it."

In his experiences with East Coast clients, he must deal with the time difference. "They are halfway through the day when we get started," he says, "so we're always a little behind during the creative part of the process. However, we always have the afternoon to work after they close, so we're always ahead during production. So it works out."

In the main, advances in electronic technology are erasing geographic boundaries. Compared to the rest of the country, many Seattle design firms such as TeamDesign have always had a jump on digital developments, so much of the cross-country communication is being done over modems.

Clients can review progress on their computer monitors on the same day the designer completes an iteration. Illustrators and photographers can forward their work digitally for immediate insertion into layouts. Video conferencing, when it arrives in force, will even add the person-to-person drama of dog-and-pony shows.

In cyberspace, everyone's in the same room.

A GOOD QUESTION: WHY SEATTLE?

Why has design excellence been allowed to flourish here in Seattle? Some say it's because of the region's spectacular scenic beauty: the wet winters and mild climate produce a verdant natural paradise of flowers and towering trees. The city itself is ringed by majestic mountains and accentuated by lakes and seawater.

Others say it's because the high level of creative energy is sparked by enormous amounts of caffeine.

A convincing explanation for Seattle's potent, fast-flowing creative juices comes from local design visionary Ted Leonhardt. He feels that here, more than in any other U.S. city, the business community is open to new ideas.

This city has long been a test market for products, movies and marketing campaigns. Entrepreneurs regularly flock here to begin new businesses: 1995 saw a record number of Initial Public Offerings (IPOs) in proportions much higher than in the rest of the country.

On the one hand, entrepreneurs choose Seattle because of the solid infrastructure of creative talent. On the other, the receptive nature of local businesspeople allows new, breakthrough design ideas to come to light.

Seattle may be insular in its geography, but it's open to fresh thinking.

THE MID-1990S: NEW FORMS OF COMMUNICATION

Almost every graphic design firm is either involved in or planning for participation in what is commonly called "New Media." Perhaps a better term, now in use at Phinney/Bischoff Design House, is "Emerging Media"; these include online communications, Web sites and CD-ROM marketing presentations.

Although much is being written and said about the new possibilities, it's obviously quite early in the game. Brad

John Van Dyke collected forty years of annual report design ideas on this CD-ROM for Mead Coated Papers.

Microsoft asked Wilcher Design to develop the MSN online site for United Airlines in early 1995.

Wressell, Electronic Operations Manager at The Leonhardt Group, notes that the general population, despite all the hoopla, is not online. Print will probably never be replaced entirely for, as Wressell admits, "I sit in front of a computer all day, so I'm not going to read on a monitor when I go home at night."

The Internet is without question an excellent research tool. But most people, when they find what they want, will hit the print key or attempt to access the actual printed piece.

Kerry Leimer acknowledges that most of their CD-ROM designs serve as supplements to a client's printed report. "No one I know is publishing annuals exclusively on disc," says Leimer, "and how long it will be before that transition is made I don't know."

As Leimer observes, Microsoft's online magazine, *Slate,* was originally intended to be in digital format only, but the Redmond software giant announced after it appeared that they will also publish a printed version. "That tells the whole story now in 1996," says Leimer.

Nonetheless, a full 85 percent of Wilcher Design's business is digital. Jim Wilcher is one of the industry's original digital designers, with a history that goes back to 1984 when he was working with a beta test of Macromedia's Director. He taught computer design at Pasadena's illustrious Art Center beginning in 1986, and created Microsoft's first commercially available CD-ROM, a presentation of Microsoft Office, in 1989.

Wilcher's portfolio includes online magazines for the New York Times publishing group and Web sites created for NBC, NPR, United Airlines and *Golf Digest*.

Digital communication offers intriguing and exciting possibilities for design firms and their clients. But it will be some time before the future is now.

TODAY: ON TO THE FUTURE

Graphic design is such a dynamic force in Seattle business today that some advertising agencies have changed their positioning lines to "Advertising & Design."

Many ad firms have even created their own graphic design divisions. Elgin/Syferd, for instance, has opened and closed such divisions over the last 15 years. John Hornall and Jack Anderson formed a design adjunct to this celebrated local agency, which lasted until they went off on their own in 1982.

Kathryn Spangler merged her design firm with a large regional advertising agency in 1988 to offer integrated marketing communications. She ended the association three years later. "I view strategic design as a critical component of an effective marketing or brand identity program," Spangler explains. "I elected to offer an integrated approach through my own firm when it became clear that the agency would continue to view mass media as the primary approach, with design as an afterthought."

Graphic design is now being embraced by other industries. NBBJ, the country's second largest architectural firm, now has an autonomous graphic design studio within its walls that creates book covers, packaging, marketing col-

lateral and other work outside the traditional realm of architecture.

What's happening to Seattle's established graphic design firms? Following the general business trends from the 1980s to the present day, many either grew dramatically or downsized to one-person shops.

Rare exceptions include Anne Traver Design, which has worked with a staff of six or seven for nearly a decade and intends to remain at that level. Leimer Cross pulls in innumerable design awards and large scale clients with a staff of seven.

But firms like The Leonhardt Group, in 1995 named the "20th Fastest Growing Private Company in Washington" by the *Puget Sound Journal,* ballooned upward to nearly 50 people.

According to the same source, Tim Girvin Design went from 18 to 55 people between 1990 and 1995, and design fees went from $1.5 million to $6.6 million. Phinney/Bischoff Design House went from 5 to 10 people, and from $310,000 to $1,675,000. TeamDesign, which wasn't even in the top 20 in 1990, now employs nearly 30 people. The Traver Company more than doubled its business with the same number of people.

Some firms choose to remain small. The Van Dyke Company prefers to limit its size so that John himself can be involved in every annual report project. "The creative process is the reason I'm in this business," says John, "and if I were in a large firm, I might be taken too far away from it."

Like Daigle Design, Edquist Design and the Z Group, many design firms prefer to remain close to their art, limiting the size of their staff. David Strong now runs a one-man shop and fulfills his desire to mentor not by running a firm of 25 people, as he once did, but by teaching basic design courses at the School of Visual Concepts.

Large or small, Seattle graphic design firms have one thing in common: a passion for producing work that outshines anything, anywhere.

It's the reason that more and more national and international companies are looking to Seattle for their next designer.

And it's the reason that, these days, Seattle companies rarely look anywhere else.

D. BETZ DESIGN

When he was 21, art student David Betz came across an issue of *Graphis* and immediately saw his career path unfold. He went on to obtain an MFA in graphic design from Kent State University, spent several years working for Michael Vanderbyl and in 1990 opened his own firm. Soon his own work was appearing in *Graphis,* as well as in *Communication Arts, Print, ID Magazine* and other major industry publications.

In 1993, David moved his business to Seattle's historic Belltown "in a 108-year-old building which started out as an Odd Fellows Hall, was turned into a sleeping bag factory and later played host to Teddy Roosevelt, W. C. Fields, Kurt Cobain, Sir Mix-a-Lot and Tom Robbins." As David suggests, "The Odd Fellows tradition continues with the arrival of D. Betz Design."

D. Betz Design serves both local and national clients, and specializes in identities, signage and packaging. According to David, his firm's expertise includes "Big Thinking, Word Smithing, Thirst Quenching, Concept Riveting, Web Weaving, Bottom Line Moving and Fire Extinguishing."

What is his strategic positioning? "D. Betz Design exists to spark the entrepreneurial spirit with ingenious ideas and compelling imagery."

Any questions?

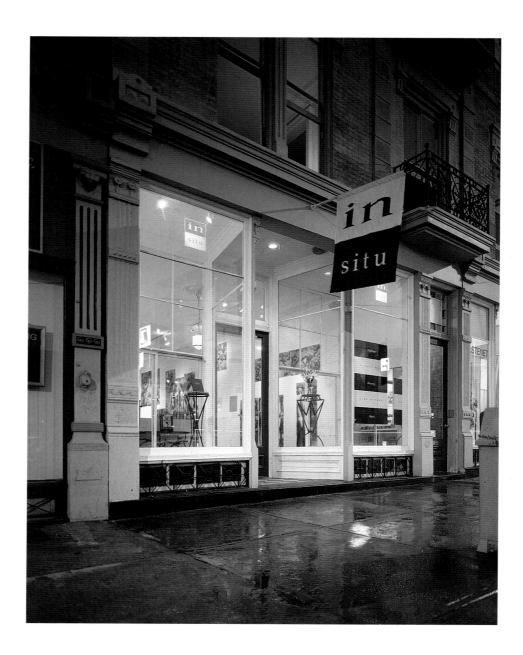

InteRetail Corporation

INTEGRA

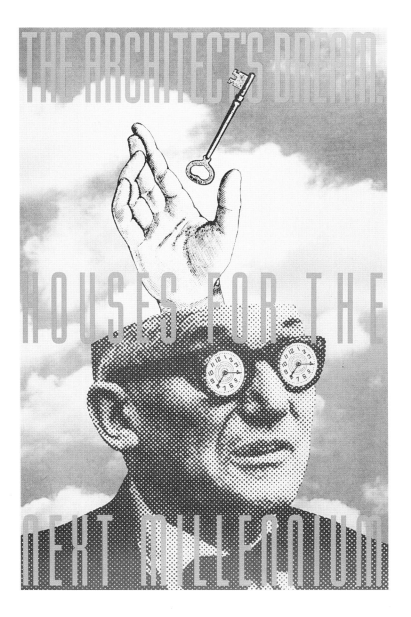

FACING PAGE: in situ Gallery identity and environmental graphics. Packaging design for Integra Technology International's Business Application Builder. CD packaging concept for Photodisc's Background Series.

THIS PAGE: Selby brand repositioning and packaging for U.S. Shoe Corporation. Exhibition poster for the Cincinnati Contemporary Arts Center. Identities for NPR Chicago's *This American Life,* Fleck's Gym, InteRetail Corporation, and Integra Technology International.

CORNISH COLLEGE OF THE ARTS

"Today, the study of design requires a much more profound grasp of tools and technology," explains Cornish Graphic Design & Illustration Program Coordinator Jo David. "It also demands a wider scope of reasoning, a deeper sense of purpose and a stronger commitment to the ideals of design excellence."

A fertile Northwest proving ground since 1914, Cornish College of the Arts continues to have excellent results in achieving its mission of preparing students to succeed as design professionals.

The school sustains a faculty/student ratio of 1 to 12 and a curriculum that encourages the development of each student's creative style.

Students work together each day to broaden their technical skills, redefine their methods of visual communication and expand their abilities as creative thinkers.

Instructors are working professionals who provide solid, experience-based training in graphic arts and an education that integrates business fundamentals with artistic passion.

Cornish offers BFA degrees in graphic design, illustration, interior design and furniture design. Graduates include Leslie Phinney, Bob Grindeland and Paula Wong, among many others. In the last few years, students have swept competitions sponsored by AIGA/Seattle.

For contributions to the Seattle design community, Cornish earns top honors.

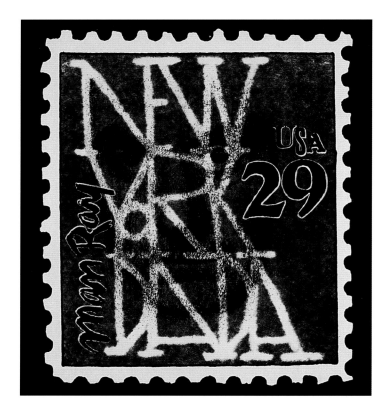

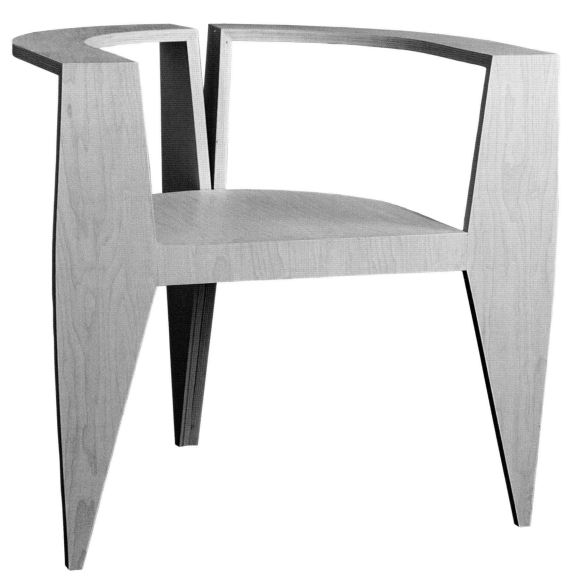

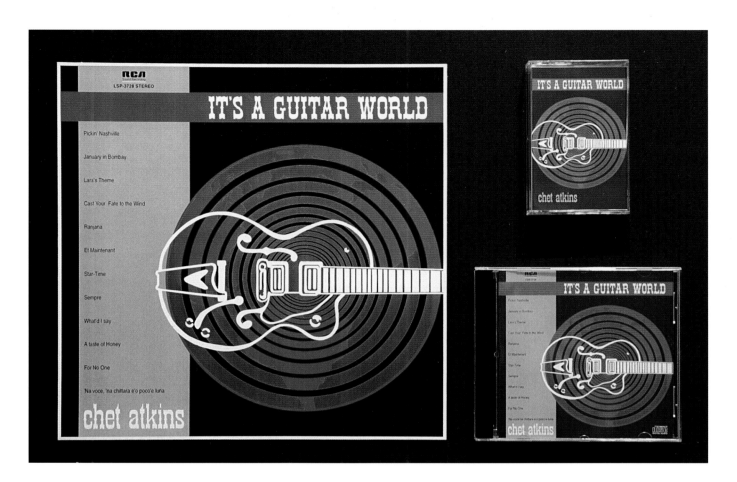

FACING PAGE: John Hubbard, Commemorative Stamp, mixed media, 1991. Paul Piacitelli, Chair, Appleply, 1994.

THIS PAGE: Blaine Carpenter, *It's a Guitar World,* CD, album and cassette cover, 1994. Bez Palmer, *Aggressive Marketing,* watercolor and colored pencil, 1996. Front view of Cornish building.

/ The aim of art is to represent not the outward
appearance of things, but their inward significance.

ARISTOTLE

DAIGLE DESIGN

Geoff and Candace Daigle founded this firm in 1987 after 13 years of industry experience in Los Angeles, Minneapolis, Honolulu and Reno/Lake Tahoe. They moved to Seattle in 1991.

Since then, the firm's talented designers have attracted clients from small start-ups to large, internationally known corporations such as Porsche and AT&T. Candace admits, "We want to see Seattle become even more of a powerful design center, much like Denmark or Italy."

Daigle Design is not your typical design firm. Most of the design group has ad agency experience, including the staff copywriter. "What makes our design effective," they explain, "is our ability to establish the unique selling position of our client."

The firm shows a powerful portfolio that includes corporate identities, logos, annual reports, brochures, catalogs, direct mail, advertisements, packaging and trade show displays.

"We enjoy selling products," reveals Geoff, "especially those which involve advanced technologies."

Daigle Design will impress clients with the economy and speed of their design, and reward them with work that consistently hits the target.

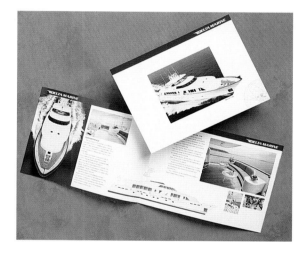

AT&T Wireless Services, cover design for annual directory of World Aerospace Technology. Delta Marine Industries, brochure design for 110' series of luxury yachts. Porsche, catalog design for 40-page sportswear and accessories catalog. Washington Software Association, promotional materials for WSA Developers Conference.

EDQUIST DESIGN

After nearly 20 years in the business, the people at Edquist Design have developed a design philosophy based on two words: *emotion* and *communication*. "Design should not only touch the audience," says Barbara Edquist. "It should clearly express what the client wants to say."

"We are, first and foremost, information designers," explains David Edquist. Does this limit creativity? "Certainly not," they respond. "Even when the objectives are clear, the design possibilities are endless."

After getting his MFA at the Cranbrook Academy of Art, David met Barbara when they both were designers at the legendary Field Museum in Chicago. Together they moved to San Francisco, where David joined Landor and Barbara worked in Michael Cronin's studio. They returned to Seattle in 1985 and started Edquist Design.

Their work encompasses "not just graphic design, but environmental design." And if there's one thing that sets them apart, it's their unbounded enthusiasm for the work. "It's always exciting to get your hands on a great project," they say, "and try to bring the solution up to new levels."

And they're not satisfied until they do just that.

The Children's Center
at Burke Gilman Gardens

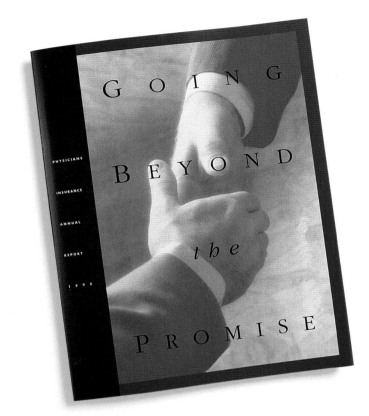

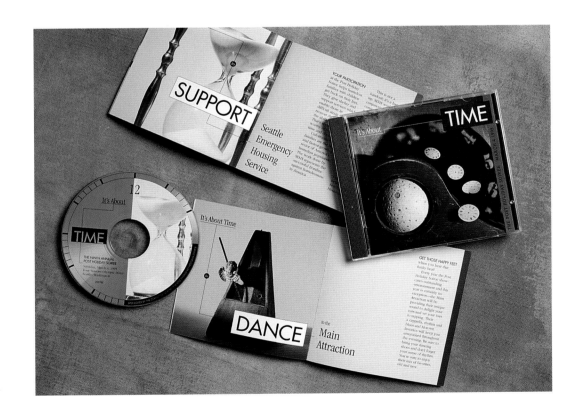

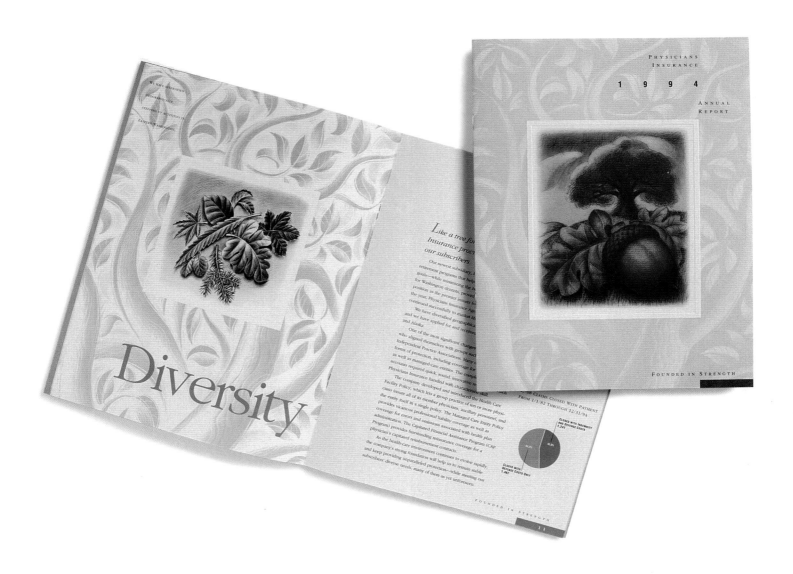

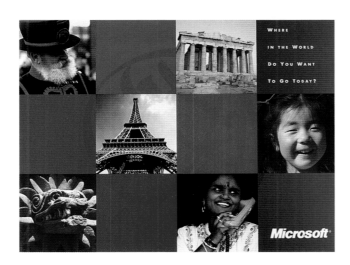

FACING PAGE: Alternapath logo, identity for insurance program covering acupuncture, naturopathy, and homeopathy, Blue Cross of Washington and Alaska. The Children's Center at Burke Gilman Gardens, identity for daycare center for low-income families. *Going Beyond the Promise,* annual report, Physicians Insurance Exchange. *It's About Time,* CD-ROM invitation to annual fund-raiser, Seattle Emergency Housing Service.

THIS PAGE: *Founded in Strength,* annual report, Physicians Insurance Exchange. Brochure for international trade show, Microsoft Corporation.

GIORDANO KEARFOTT DESIGN

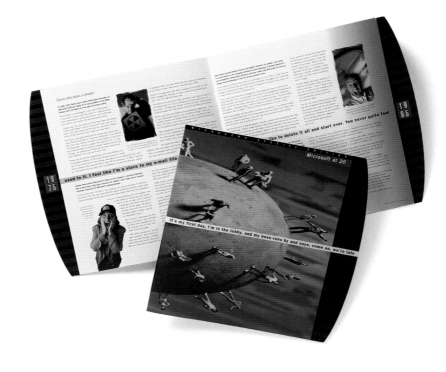

When was the last time you tried on a pair of shoes that looked great, but didn't fit? Bought them anyway. Wore them exactly once.

Design is a lot like shoes. Sure, it has to look good. But it also has to fit. At Giordano Kearfott Design (GKD), great design and perfect fit come from time spent understanding a client's project from their perspective. It's the proverbial walk-a-mile-in-your-shoes concept, but at GKD, it covers real ground.

Take the Microsoft College Recruiting Campaign for example. Microsoft wanted a Web site, print advertising, collateral, display booths, posters, and a video that presented a fresh perspective on Microsoft and living in the Pacific Northwest—topics that have been done to death. GKD's first step: understand Microsoft's goals and the target audience. Second step: really understand Microsoft's goals and target audience. End result: a fresh, effective campaign that works across all media and hits the target dead-on.

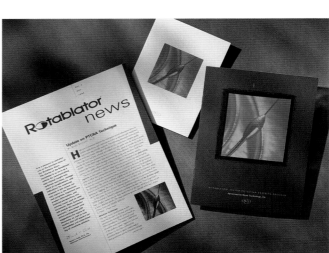

Multi-platform and non-traditional, GKD is staffed with smart people who combine their specific talents to strategize the best digital and print solutions for your project. At the heart of their approach is a mind-boggling attention to process. From initial ideas and presentation, to proofs, printing and programming, they make it all work and it shows. In the end, a client will walk away with something that feels, looks and performs exactly right. In a word, fits. Just as if someone had been standing in your shoes. From start to finish.

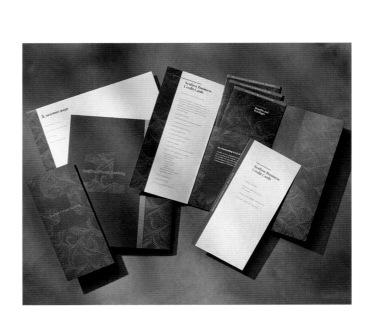

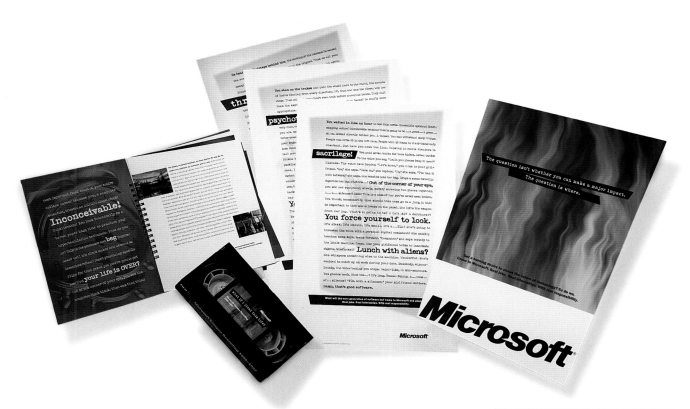

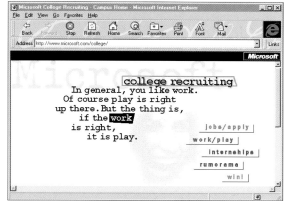

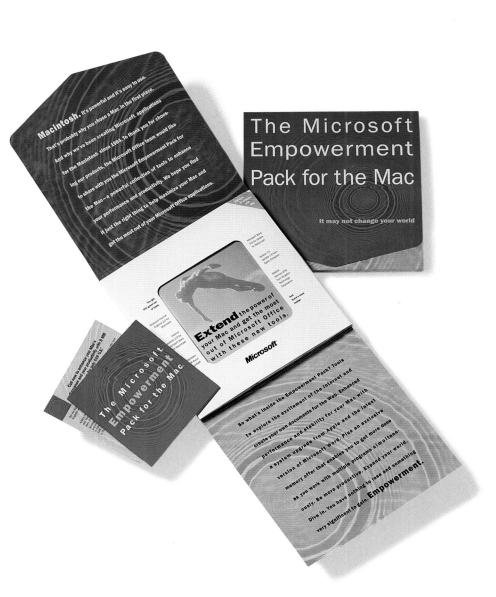

FACING PAGE: Microsoft, twentieth anniversary commemorative keepsake. SDL Corporation, logo. Symbologic, logo. Andersen, Bjornstad, Kane, Jacobs, Inc. (ABKJ), logo. Heart Technology, seminar materials. Seafirst Bank, business collateral.

THIS PAGE: Microsoft, college recruiting collateral and Web site. Microsoft, Microsoft Office for the Macintosh direct response.

TIM GIRVIN DESIGN, INC.

The truth is, you've probably
heard of Tim Girvin already.

Seattle born. Internationally
known. Leader of a group who
designs some of the modern
era's most recognized brands.

He logs more air miles than any
other Seattle designer, visiting
clients around the globe. His
firm is one of the largest on
the West Coast. His profes-
sional staff includes some of
the best in the business.

The work of Tim Girvin Design
is "International Brand & Im-
age Management." Working in
alliance with executive and
management teams through-
out the world, the firm forti-
fies the stability of existing
brands and positions new
brands in powerful, memo-
rable ways.

They employ proprietary
methodologies such as
BrandQuest™ and *Transparent
Design*™. They create meaning-
ful business opportunities for
their clients by bringing to-
gether communications that
might include Industrial De-
sign, Brand Strategy, Video,
Animation, Retail Concepts,
Exhibits or Web Spinning.

The firm has worked with ev-
ery major Hollywood studio;
Disney has been with them for
10 years. They have developed
names and identities for pre-
dominant business and con-
sumer products. They have
created collateral and online
communications for Fortune
100 companies. Their designs
fill award books.

When you produce work of
this caliber, your reputation
precedes you.

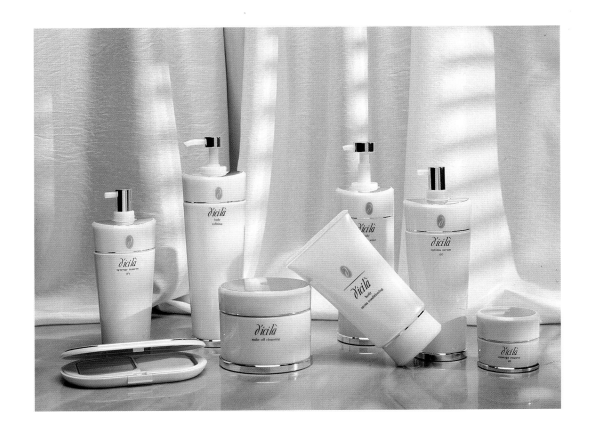

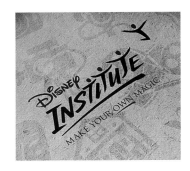

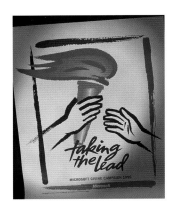

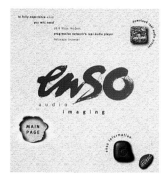

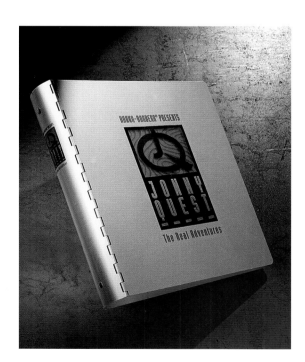

FACING PAGE: *D'ICI LÀ*/Shiseido, Tokyo, product identity, palette, packaging, signage and componentry consultation for the Japanese market. Disney Institute, Orlando, brand integration, launch materials, icons, collateral and merchandise. *Taking the Lead*/Microsoft, concept creation of campaign launch: posters, collateral and animation. Ocean Dragon, identity, brochure and collateral program for European/Asian fishing groups.

THIS PAGE: *Jonny Quest*/Hanna Barbera, identity, product creation, style guide, Quest Worlds ideation: Aero, Terra, Hydro, V.R. Enso/Muzak Web site, naming, programming, navigation, animation. Nature Conservancy/ Microsoft, 1996, Internet Explorer 3.0 launch profile site.

TIM GIRVIN DESIGN, INC.

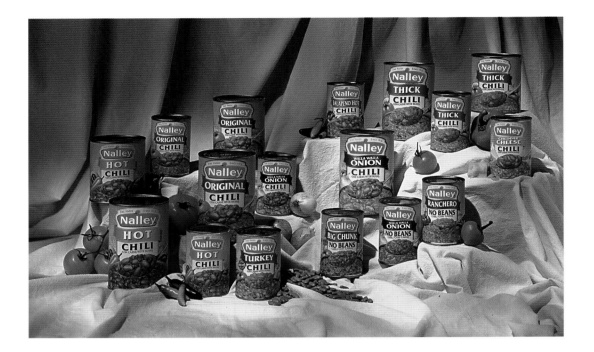

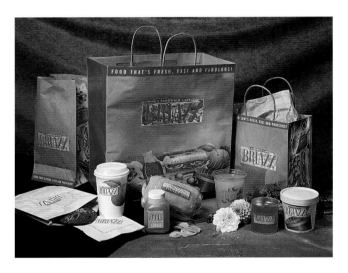

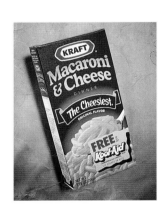

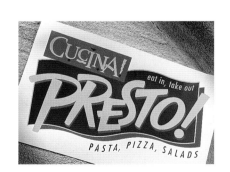

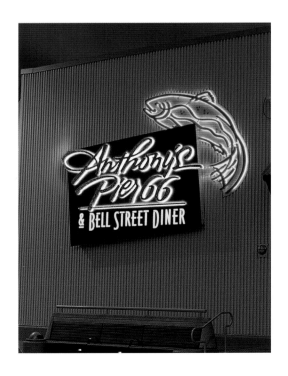

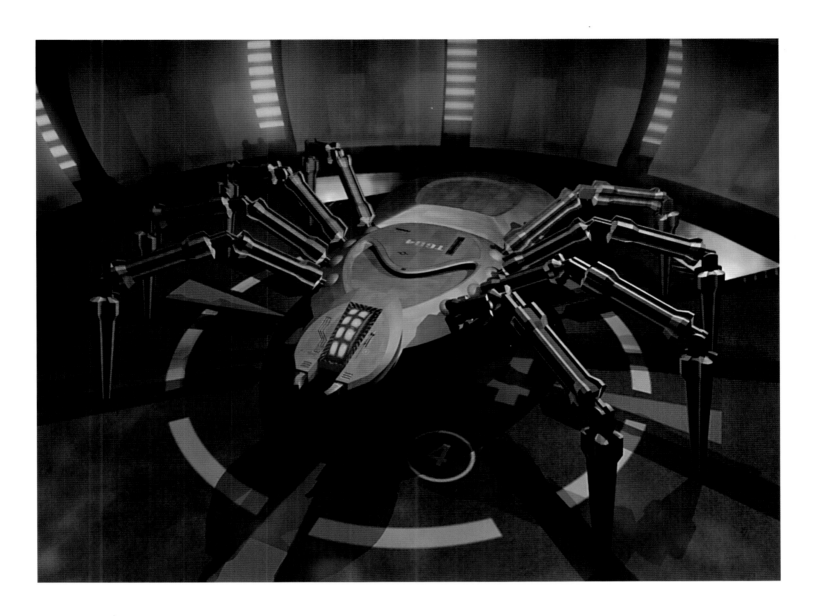

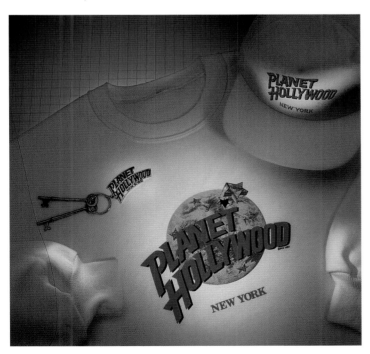

FACING PAGE: Nalley's, brand strategy, packaging for all Chili products. *Briazz*, naming, packaging, palettes and environmental graphics for this Euro-sandwich group. *Macaroni & Cheese*, Kraft, evolutionary packaging treatment for "big blue," plus flankers. *Cucina! Presto!*, identity, coloration for this spin-off from the Cucina! Cucina! brand. *Anthony's Pier 66 & Bell Street Diner*, naming, identity, signing, all collateral.

THIS PAGE: *R.A.I.D.*, SGI spider gaming animation. *Planet Hollywood*, identity development, merchandising.

TIM GIRVIN DESIGN, INC.

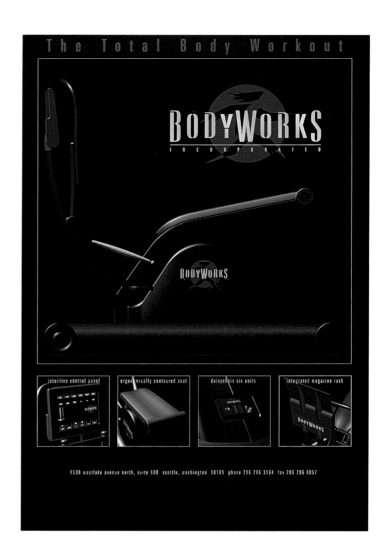

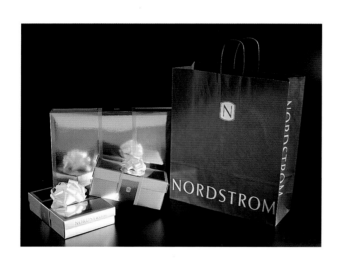

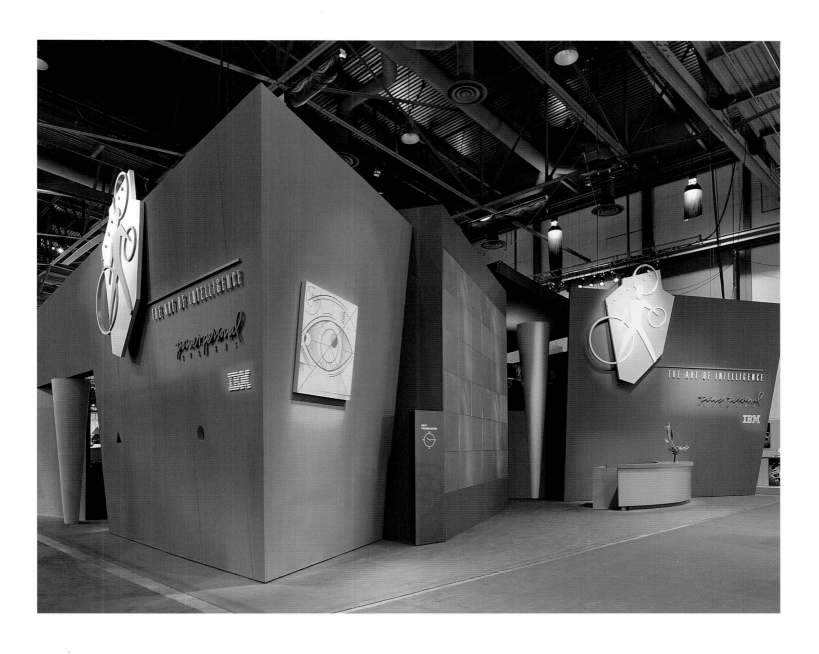

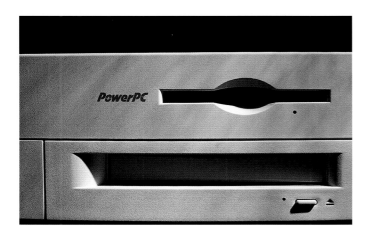

FACING PAGE: *TV Asahi*, Tokyo, corporate identity program. Nordstrom, corporate identity, standards manual, all packaging. *Bodyworks*, corporate identity, industrial design. *Spa Nordstrom*, componentry and packaging for 200 products.

THIS PAGE: IBM, Power Personal launch at Comdex. *PowerPC*, worldwide brand identity for Motorola, Apple and IBM.

HANSEN DESIGN COMPANY

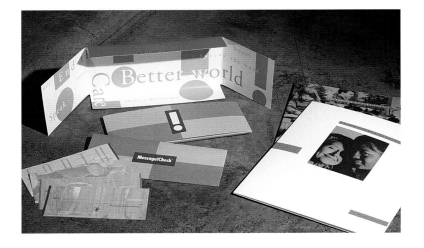

Of all the adjectives that could describe this design firm, the first to come to mind is "imaginative." Founder Pat Hansen insists that every project have a strong concept behind it—a practice that has earned Hansen Design Company a reputation for being a "great idea" firm. This passion for creativity has earned international recognition and hundreds of awards.

Pat has done more for the Seattle design community than most. She was a founding officer of Seattle Women in Design (later the Seattle Design Association). In 1986 she was founding president of the American Institute of Graphic Arts/Seattle, and later served on the AIGA's National Board of Directors.

From corporate identity materials to design for new media, from planning a communications strategy to implementation, the firm works with the client's unique perspective and audience in mind. "That's why you'll see amazing diversity in our portfolio," says Pat, "from zany to elegant."

Another adjective that fits this firm is "resourceful." If there's a way to get something done, Pat and her staff will find it. They know how to get the most value out of any budget, large or small.

Unique perspectives backed by great ideas: it's a combination that keeps the work fresh and keeps clients coming back.

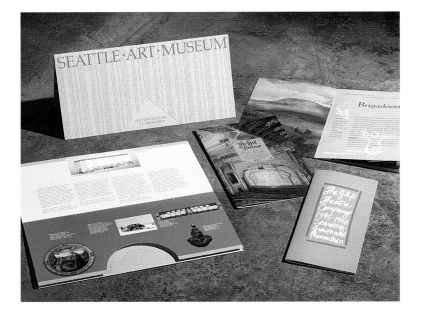

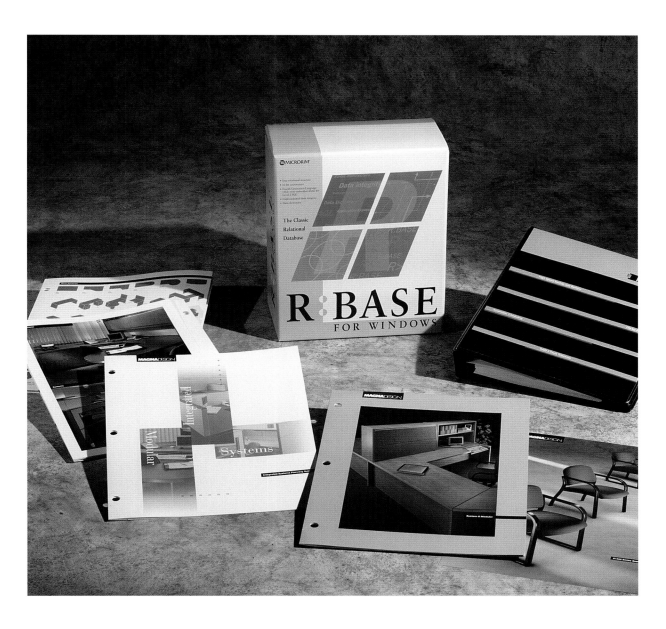

FACING PAGE: Message!Check Corporation, identity, personal check designs, gift packaging; United Way of King County, 1992 campaign materials. Columbia Bank, logo. eMedia, logo. The Well Made Bed, logo. Westin Shanghai Cafe Bistro, logo. Seattle Art Museum, capital fundraising brochure; The Fifth Avenue Theatre, season brochure; The G.A.P. Theatre Company, season brochure. Robert Leonard Salon, collateral and gift packaging.

THIS PAGE: Microrim, packaging for R:Base for Windows; NetFRAME, DataJET identity and packaging; Magna Design, promotional sales materials. AT&T Wireless Services, direct mail brochure; Microsoft, new product documentation (Creative Writer, Fine Artist, Magic School Bus Programs).

HORNALL ANDERSON
DESIGN WORKS

Ask national and international companies what they know about the Seattle design scene, and they'll probably name Hornall Anderson Design Works. A local design powerhouse, the firm's work is recognized hundreds of times each year in competitions worldwide, often receiving top honors.

What drives such a high level of creativity? "Passion," answers John Hornall. As Jack Anderson explains, "John and I lead by example, and work with gifted and imaginative designers who are passionate in their pursuit of excellence."

One of the city's largest firms, Hornall Anderson provides a global scope of services encompassing corporate identity, branding, packaging, literature, exhibits and signage systems. They have "tremendous depth on the bench" and rely on teamwork to come up with great ideas.

Each project is controlled by a series of benchmarks to ensure that the work is meeting brand strategies, positioning the product or service where it will excel. The client is a partner throughout the process.

"A partnership relationship with the client," says John, "is the heart of great design." This attitude is well appreciated. The firm's repeat business rate tops 75 percent as a rule.

And the awards keep pouring in.

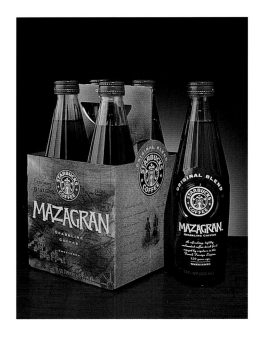

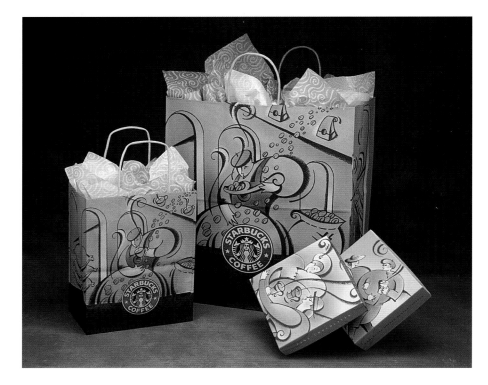

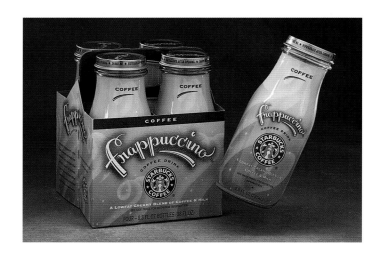

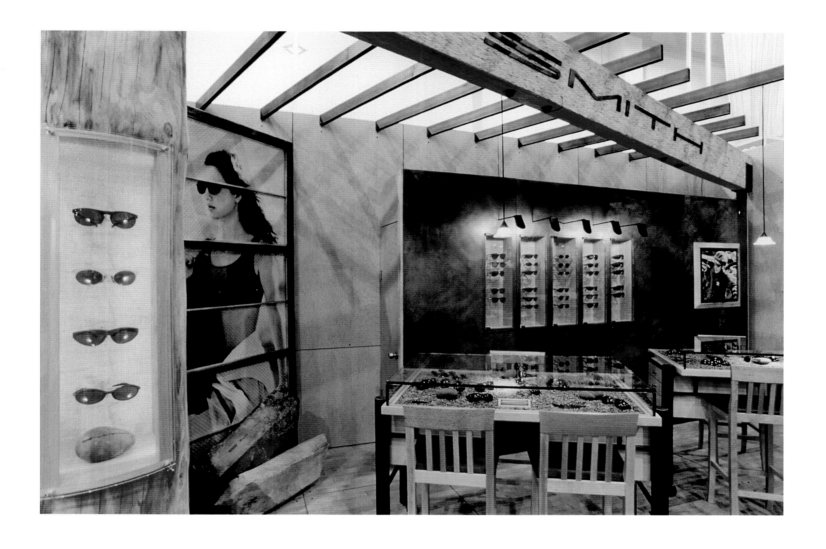

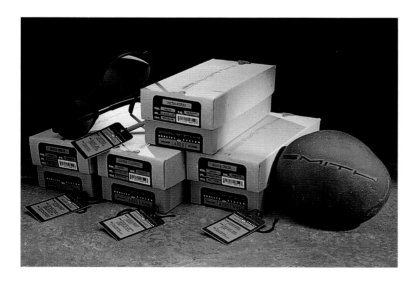

FACING PAGE: Starbucks Coffee Company Mazagran sparkling coffee four-pack and bottle packaging. Logo for McCaw, a provider of wireless services to foreign and international markets. Starbucks Coffee Company shopping bags and fine chocolates packaging. Starbucks Coffee Company Frappuccino coffee four-pack and bottle packaging.

THIS PAGE: Smith Sport Optics tradeshow exhibit booth. Smith Sport Optics sunglasses packaging and point-of-purchase display rock.

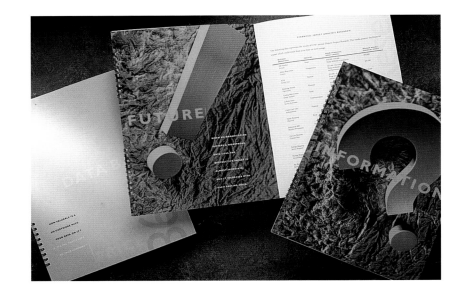

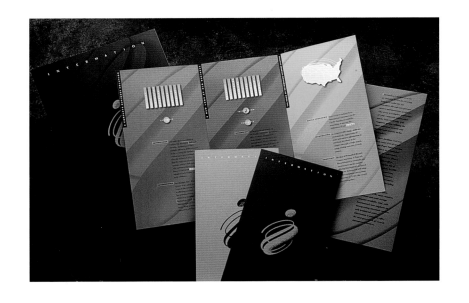

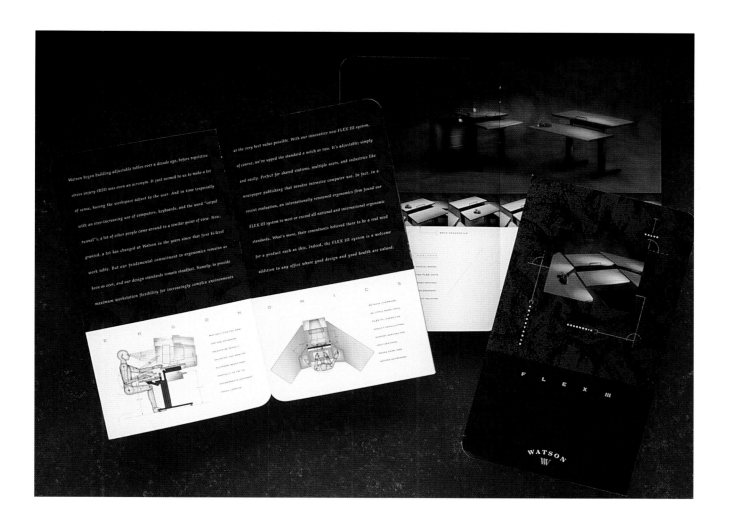

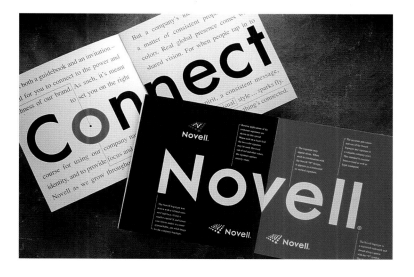

FACING PAGE: Starbucks Coffee Company 1995 annual report. Logo for Corbis, a digital image archive. Logo for Capons Rotisserie Chicken, a restaurant chain. Data Base capabilities brochure. Logo for Xcell, a nutritional, isotonic drink for athletes. Logo for University Village Shopping Center. Intermation Corporation marketing folder and brochures—part of a complete identity program.

THIS PAGE: Watson Furniture Company Flex III brochure. Novell Corporate Identity Guidelines brochure.

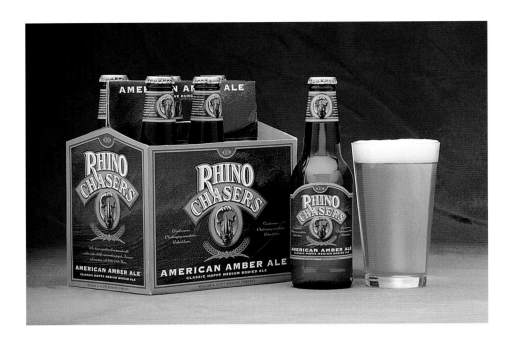

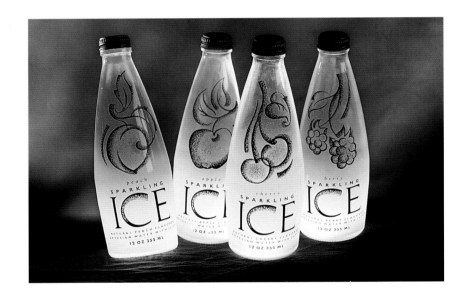

HORNALL ANDERSON
DESIGN WORKS

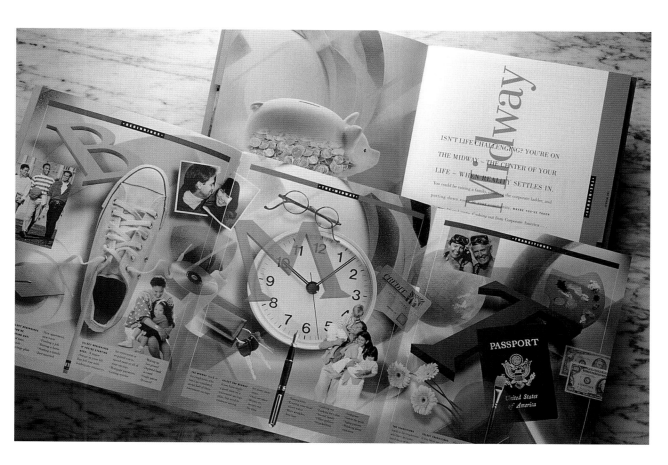

FACING PAGE: Rhino Chasers six-pack and bottle packaging. Logo for Pacific Coast Feather Company, a manufacturer of down feather products. Talking Rain, sparkling ICE bottle packaging. Airborne Express 1993 annual report.

THIS PAGE: Jamba Juice bags. Frank Russell Company LifePoints brochure. NEXTLINK Corporation capabilities brochure. Logo for NEXTLINK, a full-service telecommunications provider specializing in the next wave of communication products and services.

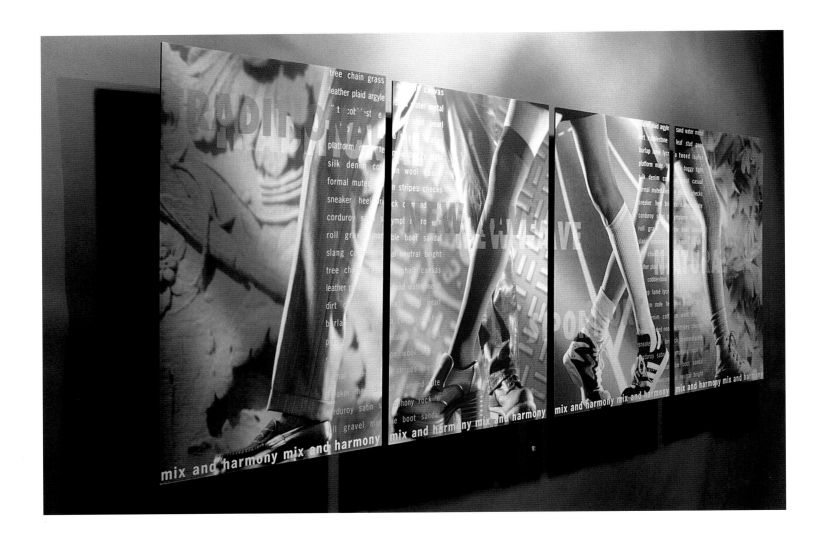

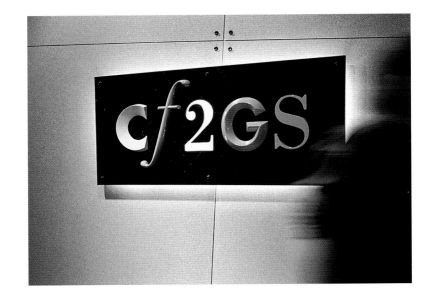

THIS PAGE: Okamoto Corporation tradeshow posters. Cf2GS signage.

FACING PAGE: Logo for XactData, a distributive system backup company. Logo for Onkyo, an electronic equipment manufacturer. Microsoft Corporation Global Summit award. Quebecor Integrated Media stationery—part of a complete identity program. Alki Bakery packaging.

HORNALL ANDERSON
DESIGN WORKS

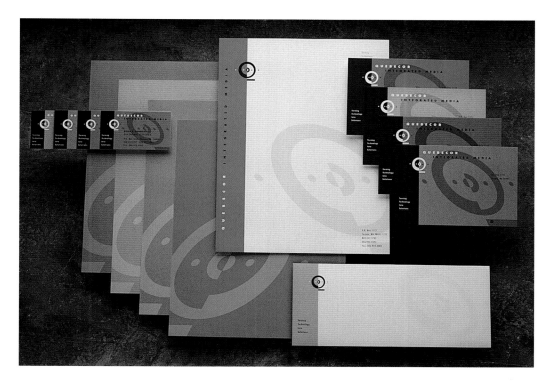

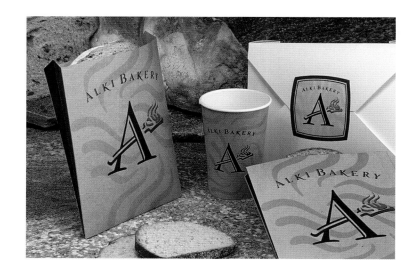

ILIUM ASSOCIATES, INC.

Founded in the Seattle area in 1972, Ilium has long been recognized as the leading design firm for large-scale transportation systems throughout North America. In the past few years, they have grown dramatically and expanded their market reach. Current assignments include software packaging, real estate development, signage systems and consumer products.

The secret of their success? Says Vice President Don Sellars, "Few design firms operate with as much emphasis on market research, strategic planning and client communication."

Ilium believes that the best results come from client interaction. Clients often enjoy the luxury of choosing from several excellent options because Ilium understands that there is usually more than one way to meet a creative challenge.

"What really sets us apart," says President Carolyn Andersen, "is our ability to look at the big picture. Every single project must fit into our client's overall marketing strategy. The creative solutions must be appropriate."

Big-picture perspectives. Attention to detail. No wonder Ilium is earning more and more national recognition.

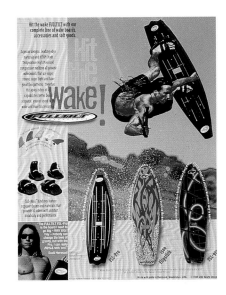

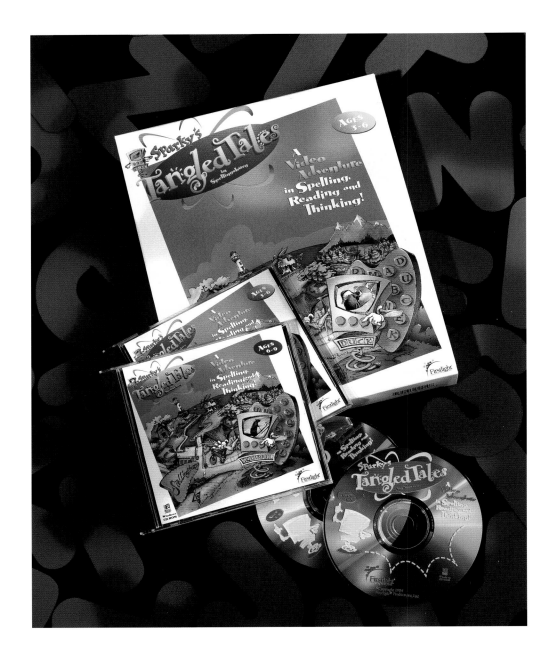

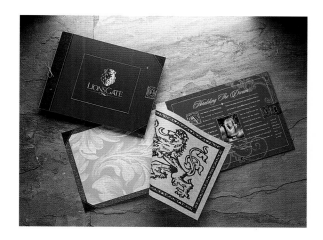

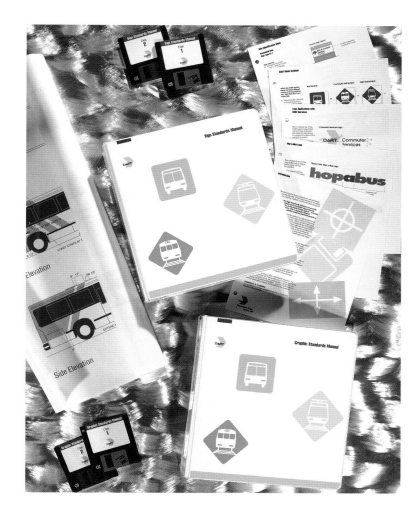

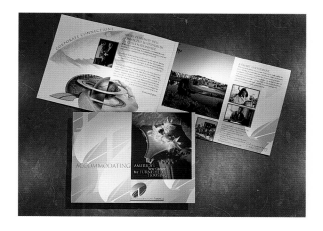

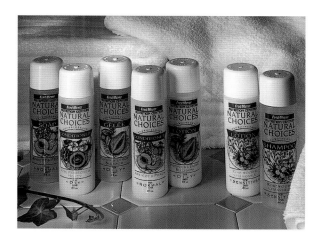

FACING PAGE: Design of several CD-ROM multimedia product packages for Firstlight Productions, Inc., including Sparky's Tangled Tales, GateKeeper and Editor's Choice. Development of national consumer advertising and an international product line brochure for US2 Sports' FullTilt snowboard and wakeboard products.

THIS PAGE: Development of graphic and signage standards for the Dallas Rapid Transit. Identity, signage, advertising and marketing communications for several multifamily developments for Trammell Crow Residential, including LionsGate. Identity and marketing communications for Accommodations America. Packaging design for Natural Choices bath products.

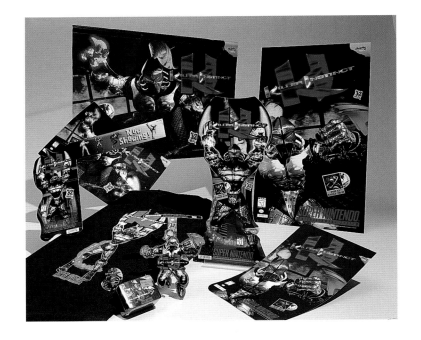

IMAGE INK STUDIO

Founded in Bellevue in 1977, Image Ink Studio quickly grew to a mid-sized firm. And stayed a mid-sized firm. "We have deliberately limited our size," notes principal Dennis Richter, "in order to maintain a close, personal involvement with our clients on every project."

Clients tend to stay with them. Image Ink has been working with Microsoft since 1979, and with Nintendo for over 14 years. Both companies enjoy the emphasis on "results-oriented graphics."

Lengthy experience with high-tech clients has required that Image Ink designers become technically astute. And they have. "We've always been on top of computer technology," says co-principal Blake Barfuss, "and that allows us to be both extremely cost-effective and highly creative."

For Image Ink, creativity means "real-world solutions." As Dennis explains, "We've certainly won our share of awards, but we pride ourselves on providing design solutions finely targeted to our clients' marketing goals."

And that's another reason clients stick with Image Ink.

FACING PAGE: Nintendo TV promotional logo. Nintendo Killer Instinct introductory point-of-sale campaign. Continental Mills corporate brochure. Continental Mills employee benefits package.

THIS PAGE: Ostex International corporate logo. Microsoft Gold Rush campaign logo. Nintendo counter cards and mobiles. Microsoft Softimage promotional bag.

LANDOR ASSOCIATES

Why would a design firm with 18 worldwide offices open a studio in Seattle? Because Microsoft asked.

In 1995, Microsoft selected Landor Associates as its design partner for all packaging, associated collateral and product identities. Landor Seattle instantly became one of the area's largest design firms.

Although new to Seattle, Landor has been creating identities and brands since 1941, when German expatriate and Bauhaus-trained designer Walter Landor founded the company in San Francisco. A legendary pioneer in this field, Walter used consumer research to turn design into a powerful branding tool.

"Never assume" is a Landor maxim. Diligent research and analysis fuel an entire range of creative disciplines. A flexible process of creative development is applied to deliver carefully crafted solutions.

Worldwide, Landor Associates' clients include FedEx, Xerox, PepsiCo and Cathay Pacific Airways. Landor has been retained for the Olympic Winter Games in Nagano, Japan (1998), and Salt Lake City (2002).

Locally, more and more Pacific Northwest and Pacific Rim companies are calling on Landor Seattle.

The firm combines a global network of resources with the accessibility of a local firm. These strategic designers, writers and name developers offer every client a world of expertise.

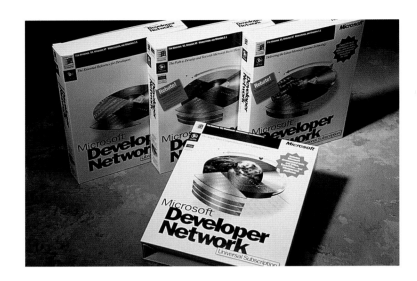

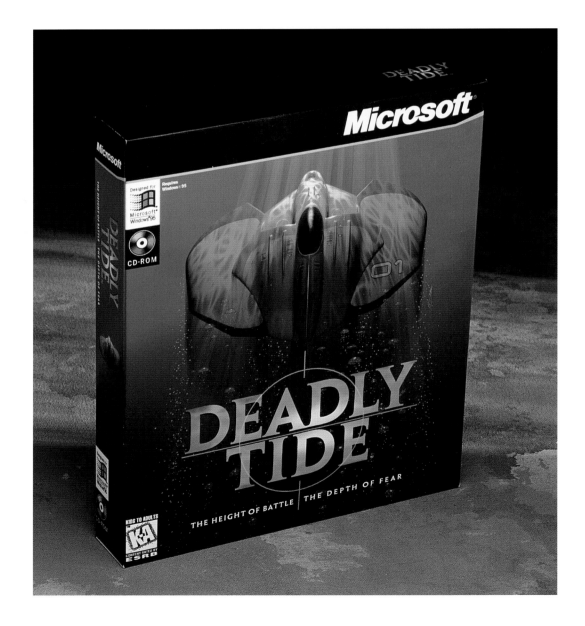

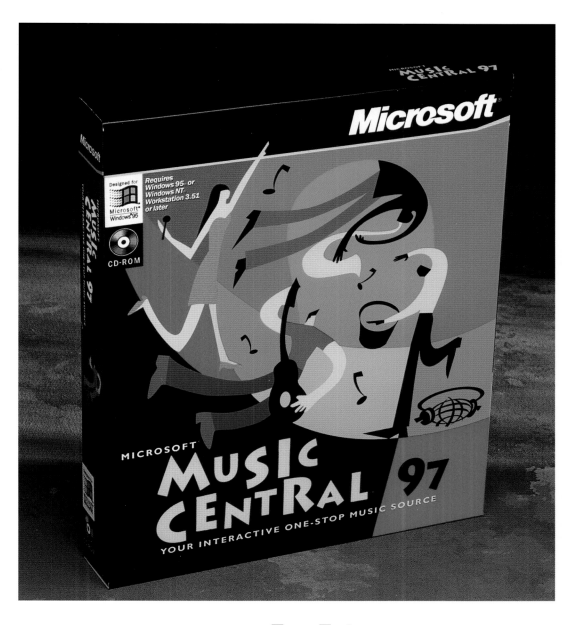

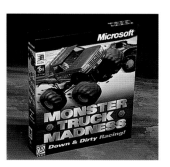

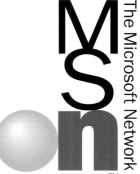

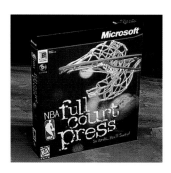

FACING PAGE: Microsoft Developer Network—A unique packaging system was created for this series of software-development products. Deadly Tide—Intense graphics and copy were crafted to command attention in the crowded software game market.

THIS PAGE: Microsoft Music Central 97—A lyrical composition was designed for the sophisticated music audiences of Europe. MSN, The Microsoft Network—A new, bold identity was crafted to establish MSN as the premier source of online information, entertainment and Internet access. Also shown are Microsoft 3D MovieMaker, Monster Truck Madness and NBA Full Court Press.

LANDOR ASSOCIATES

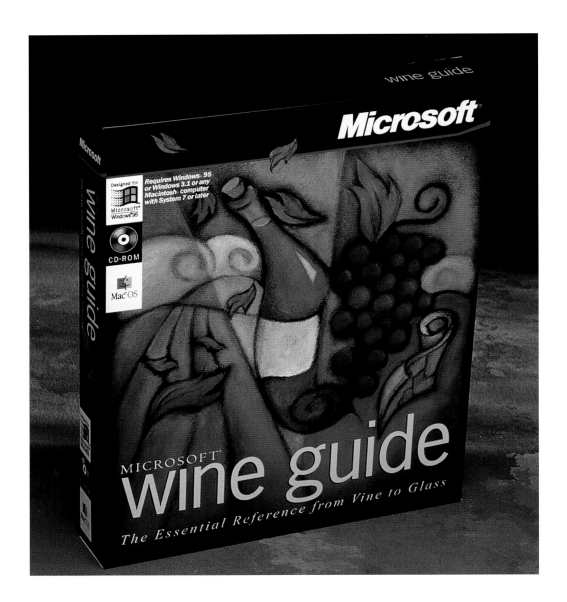

THIS PAGE: Microsoft Wine Guide—This package elegantly reflects the qualities of fine wine and targets the international consumer market. SolutionsIQ—Landor utilized a sophisticated wordmark as the new corporate identity for this computer consulting firm.

FACING PAGE: Bert Grant's beers—Brewing tradition and expert craftsmanship are clearly signaled in this new identity and packaging for the Yakima Brewing & Malting Co.

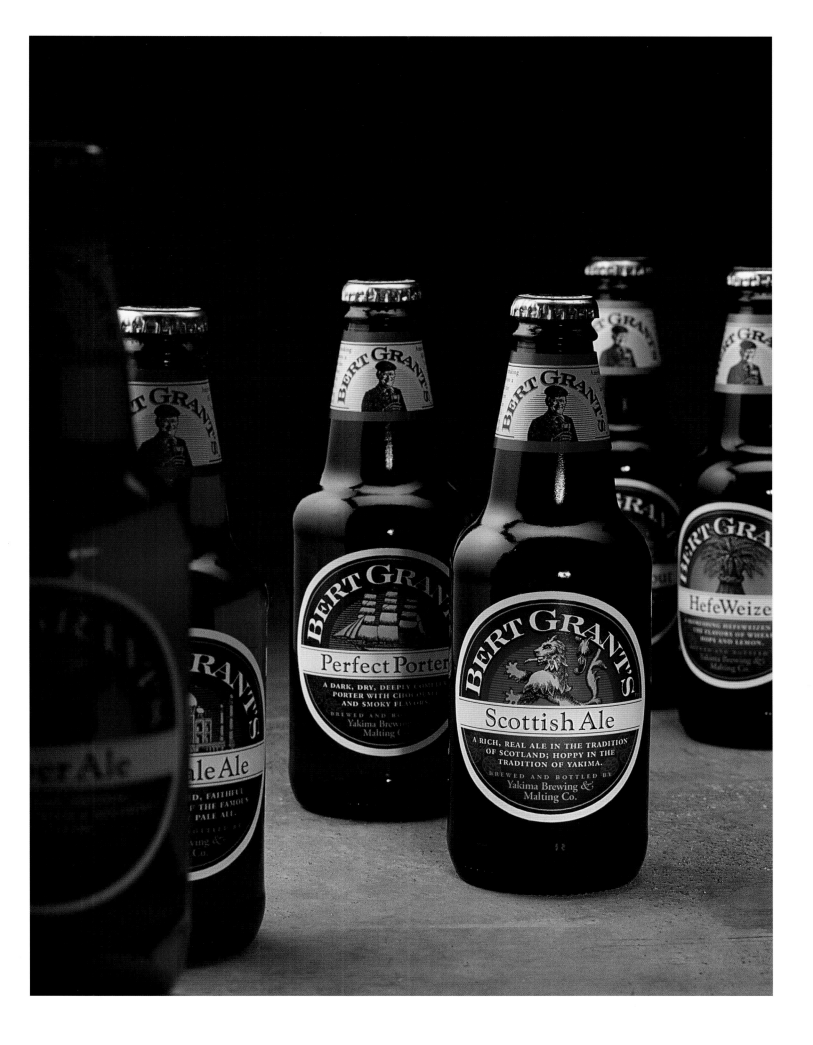

LEIMER CROSS
DESIGN CORPORATION

"Our approach to corporate communications is content-driven," says principal Kerry Leimer. He personally writes five or six of the 20 annual reports the firm produces each year, and concentrates on "merging text and design into one cohesive concept." His primary emphasis is on communicating the client's message in documents that are, as Leimer puts it, "seamless, unique and memorable."

Inarguably the leading annual report design firm in the Pacific Northwest, Leimer Cross possesses the largest market share and the highest ratio of awards. Since founding the firm in 1983, Leimer and partner Dorothy Cross have established themselves as one of the top 15 annual report design offices in the United States. Clients include public companies in New York, Toronto, Vancouver, B.C., Portland, San Francisco and Seattle.

Many clients approach Leimer Cross first for annual reports. Then, impressed with the firm's uncompromising creative and production standards, they commission other print and electronic communication projects such as shareholder presentations and other corporate collateral.

In the past five years, the firm has been recognized in all the top annual report competitions. Consequently, Leimer has also been selected to judge many of the major shows, including AR 100, Mead Annual Report Show, Simpson and *Communication Arts*.

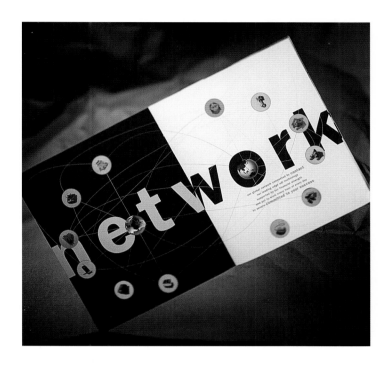

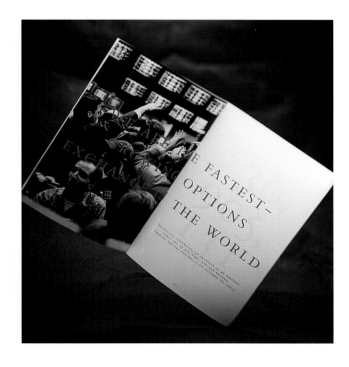

THIS PAGE: Corporate film for
1995 Penwest annual meeting.
1995 Penwest annual report,
Seattle.

FACING PAGE: 1993 annual report
for Aldus Corporation, Seattle.
1995 annual report for ZRC,
New York. 1995 annual report
for Quality Food Centers,
Seattle.

THE LEONHARDT GROUP

Founded back in 1976, Ted and Carolyn Leonhardt's office is today the fastest-growing design firm in Seattle.

What is The Leonhardt Group doing right? For starters, they have a proprietary design approach. For every client, they create a Visual Vocabulary™ system—a collection of visual elements and a flexible pattern for using them. This ensures that all subsequent design solutions will be consistent with the client's unique image.

The firm's positioning line is *Design: Image & Meaning*. "You always have two objectives in design," they explain. "You must create a powerful image, and convey a meaningful message."

Graphic design is their core business, but they use multidisciplinary teams to deliver service. Project teams are assembled from five groups: account service, electronic art, production management, administration and design.

Clients love meeting at The Leonhardt Group. The firm occupies two floors of an art-deco landmark erected in 1928, the year after Ford unveiled the Model A. The historic interiors were preserved, and the space pulses with creative vitality.

A conducive workspace. A proven process. A commitment to producing nothing less than great work. It's no wonder TLG is growing so fast.

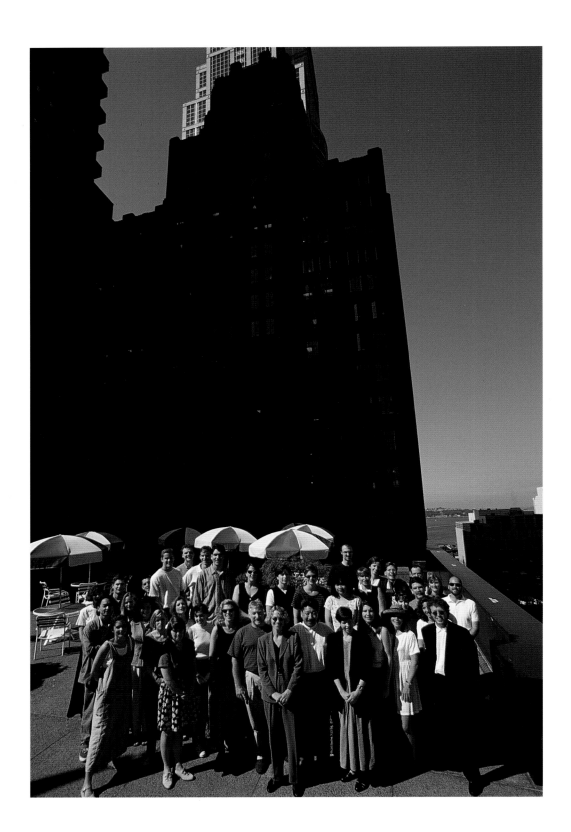

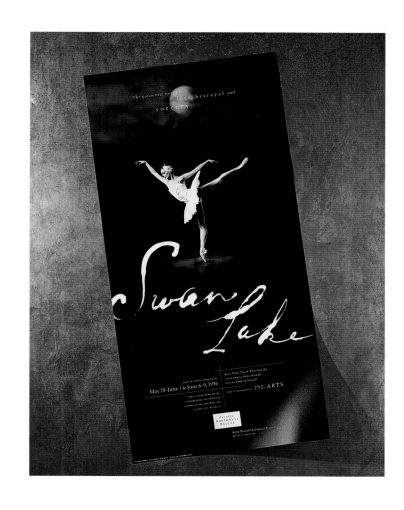

Mosaix

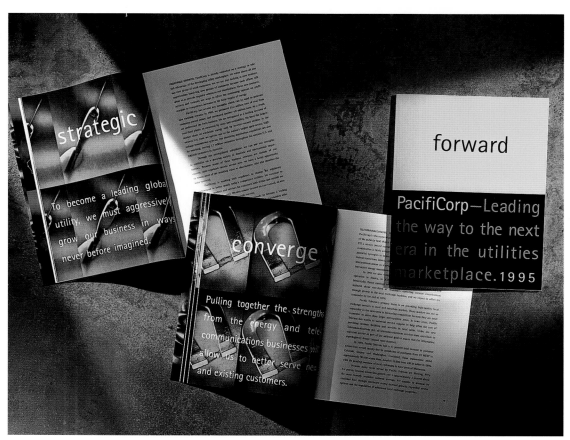

FACING PAGE: TLG staff on their deck in the historic Seattle Tower. Get inside at www.tlg.com.

THIS PAGE: New brand identity program for Mosaix, formerly Digital Systems International, developers of call management systems, software and services. Pacific Northwest Ballet poster; TLG has helped PNB steadily increase audience size since 1984. PacifiCorp 1995 annual report communicated a major strategic change for the largest electric utility in the West; the design won international acclaim in the prestigious "AR100."

THE LEONHARDT GROUP

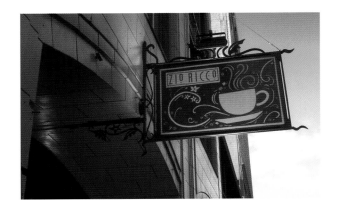

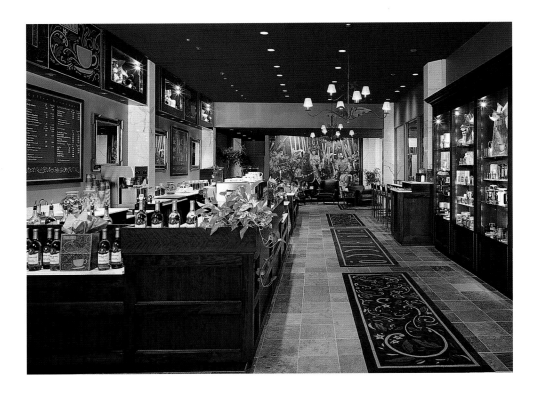

THIS PAGE: Zio Ricco blade sign; TLG named this chain of up-scale urban coffee shops and designed the identity. Zio Ricco interiors; TLG applied the identity throughout, using their proprietary Visual Vocabulary™ design system. REI environmental graphics for the famous outdoor outfitter's new Flagship store.

FACING PAGE: Hogue wine packaging, a revolutionary design for this nationally respected Washington State winery, a client since 1984; TLG also designed the winery's Web site at www.hogue-cellars.com.

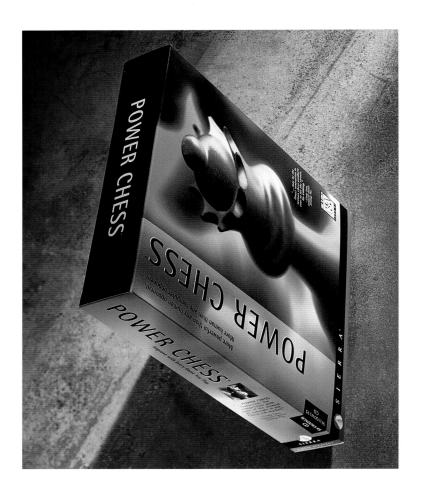

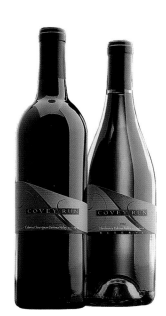

THIS PAGE: Sierra On-Line packaging for Power Chess on CD-ROM. Covey Run label redesign doubled sales of this wine in one year; innovative paper engineering anticipated market trend. Nile Spice packaging introduced the company's organic product line to mainstream supermarket shoppers.

FACING PAGE: Ovid sales literature, annual report and new identity established a powerful brand for this Manhattan-based software company. Gargoyles sunglasses marketing materials, produced in a very short timeframe.

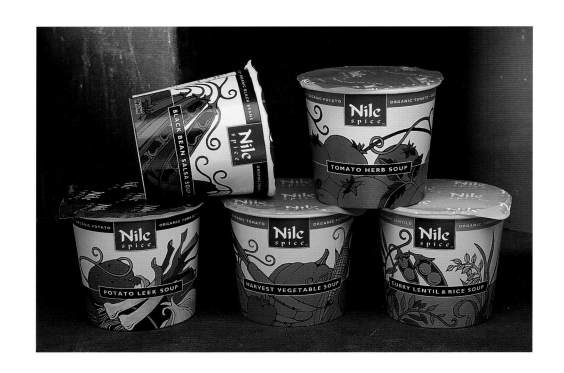

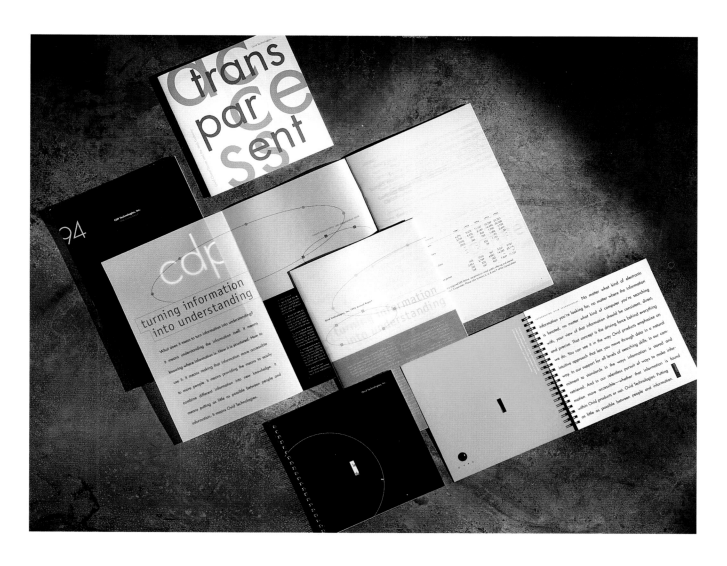

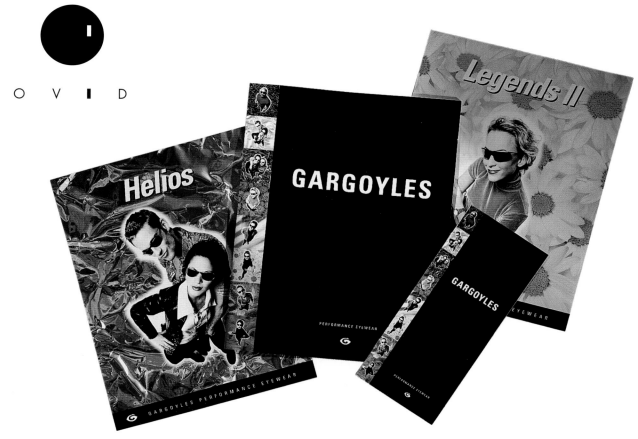

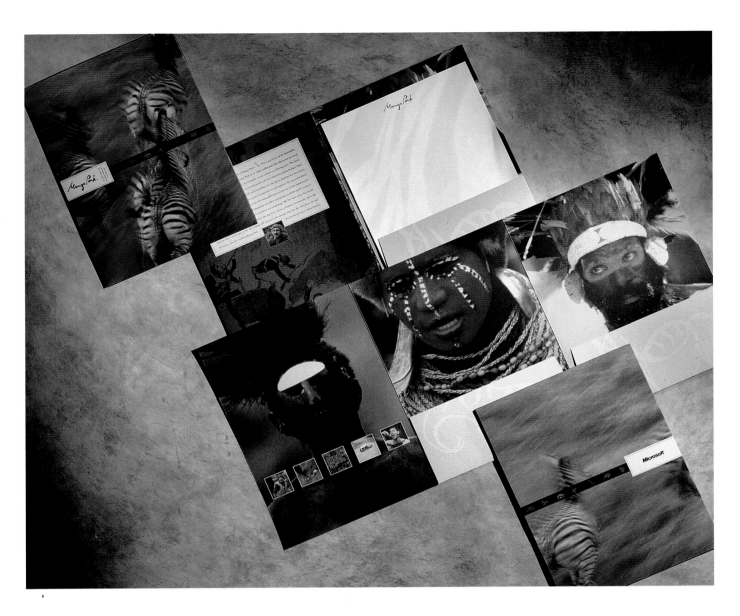

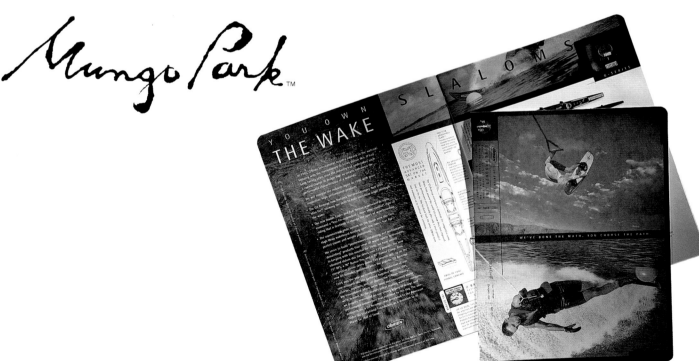

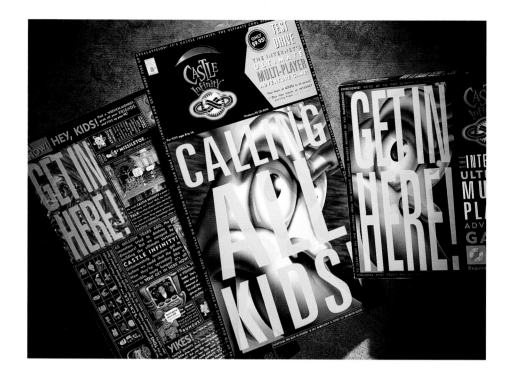

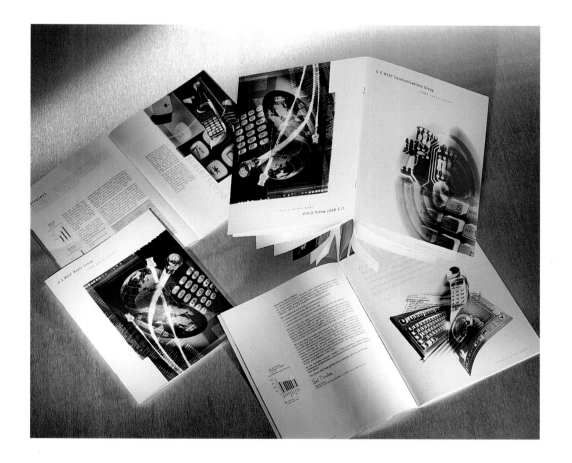

FACING PAGE: Mungo Park marketing materials for Microsoft, a client since 1981 when TLG helped launch the Microsoft Word program. Microsoft® Mungo Park™ identity for an exotic, online travel magazine. O'Brien waterski product catalog used a wonderfully irreverent approach geared to young adventurers.

THIS PAGE: Packaging for Castle Infinity, the Internet's first multiplayer game for kids from Starwave. U S WEST annual report 1995, their first year reporting as a targeted-stock company. The book features two covers representing two sides of the company.

NBBJ
GRAPHIC DESIGN

Here is a design firm that operates outside traditional boundaries. For one thing, although they appear in many design annuals, you won't find them in the yellow pages. For another, they share the name of a 50-year-old company known more for architecture than for graphic design.

NBBJ Graphic Design was founded in 1985 to support the marketing department of NBBJ, the nation's second largest architectural firm. Today, as an autonomous studio, talented designers handle an eclectic mix of projects including brand identities, marketing collateral, book design, retail packaging and even theater posters.

"Much of our business comes from client referrals," says co-principal Susan Dewey. The firm's reputation is based on both creative talent and a service-oriented approach to providing solutions. More than one client has said, "They made my life easier."

According to co-principal Kerry Burg, the firm's philosophy is rooted in accountability: "We really do understand the business needs of our clients, especially those involving tight schedules and limited budgets."

This attitude, coupled with the powerful depth of creative talent, assures that an NBBJ design will be attention-getting, results-oriented and, from the client's viewpoint, effortless.

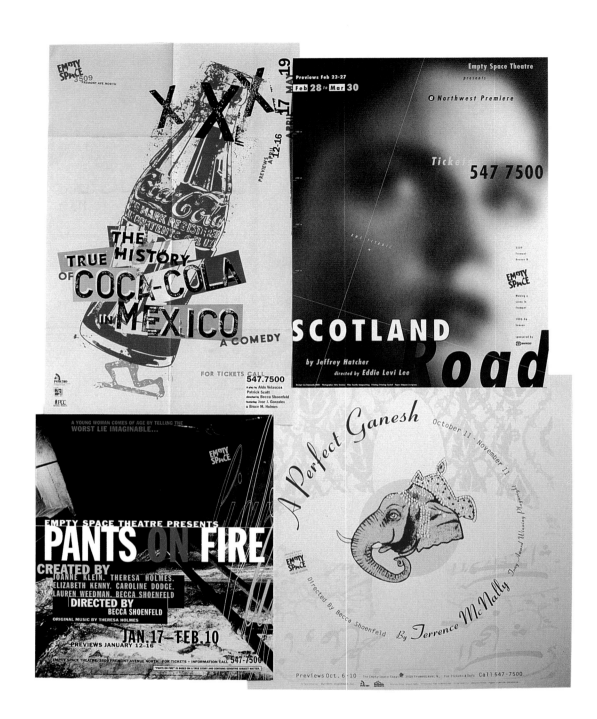

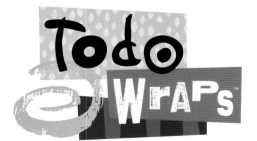

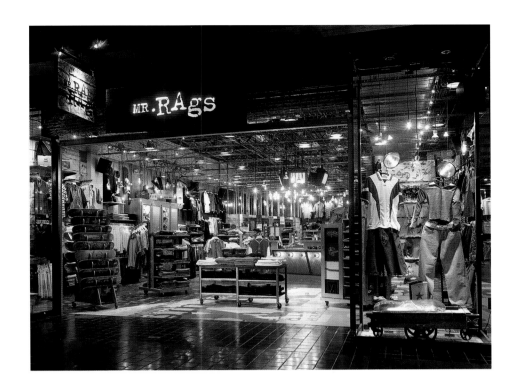

FACING PAGE: Empty Space
Theatre 1996 poster series.
Todo Wraps identity.
THIS PAGE: Mr. Rags clothing
store identity and environ-
mental graphic design. NBBJ
Sports and Entertainment divi-
sion identity. LandDesigner 3D
software packaging for Sierra
On-Line, Inc. Todo Wraps
merchandising and packaging
concepts.
PHOTO CREDITS:
Nelson Miyazaki (Todo Wraps)
Julia Russell (LandDesigner)
Steve Keating (Mr. Rags)
Jeff Helman (Empty Space
Theatre)

PHINNEY/BISCHOFF
DESIGN HOUSE

"Creative passion is paramount," says Leslie Phinney, "but effective marketing communications need a good, solid strategy."

Each Phinney/Bischoff project begins with a comprehensive questionnaire which clients complete. The results are translated into a creative platform. This exercise has earned the firm kudos for their consensus-building skills in large corporations.

Rated by business journals as one of the top 10 design firms in the Northwest—a remarkable position for their size—Phinney, Bischoff and crew operate from an exquisitely restored 1910 house on Seattle's colorful Capitol Hill. The 12-year-old firm serves many well-known U.S. companies, providing design services such as print, multimedia and advertising. But Phinney/Bischoff doesn't stop there.

"You might call us futurists," says partner Karl Bischoff, head of the firm's Emerging Media division. "We are offering more and more electronic communication services as part of our clients' marketing mix," he says. "Our work in video, broadcast and interactive media such as Web sites and CD-ROMs has tripled in the past year."

Since Phinney/Bischoff combines a passion for design with a sense of responsibility, clients find working with them is both fun and rewarding. "And that's when the best work happens."

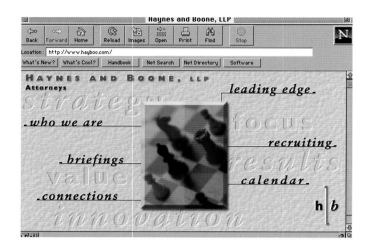

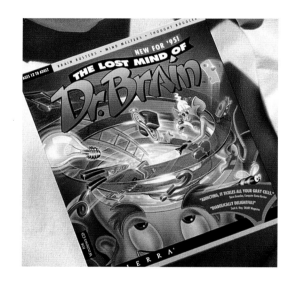

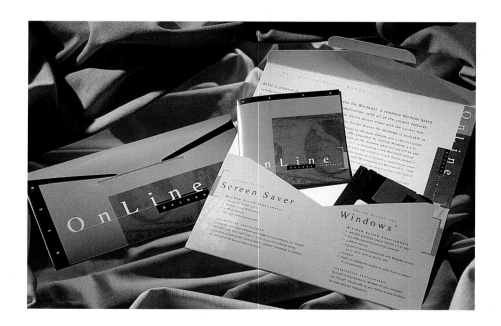

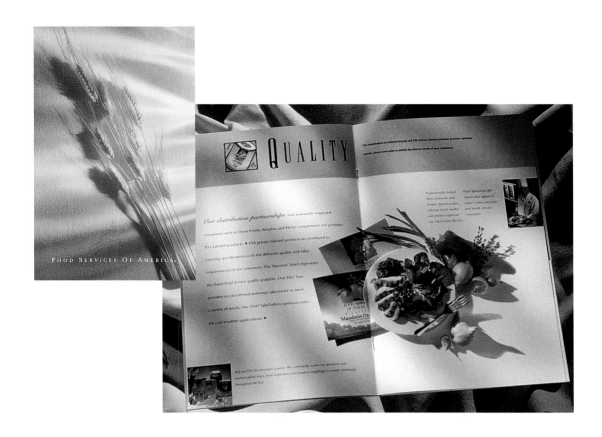

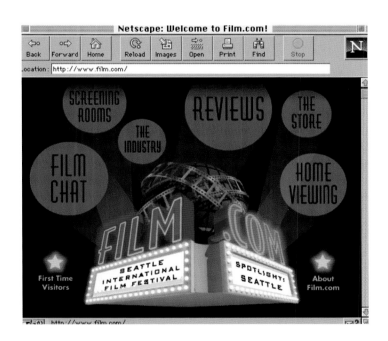

FACING PAGE: Haynes and Boone Web site home page screen. Sierra On-Line packaging for Dr. Brain CD-ROM game. Boeing Employees Credit Union direct mail packaging for OnLine Access for Windows.

THIS PAGE: Food Services of America capabilities brochure with customized inserts to promote regional services. Film.com Web site home page screen. Business Travel Northwest logo. Converter's Resource, Inc. award-winning logo (American Corporate Identity 1996). The Bon Marché Pine Street Gourmet logo for the specialty food and gift department.

KEN SHAFER DESIGN

Ken Shafer was drawing letterforms when he was six years old. "My father was a sign painter," says Ken. "He showed me how to draw the thick and thin components of letters with a single stroke." In high school, when other kids were sketching race cars, Ken doodled letters.

In 1989 he left Dallas, where he had worked with Woody Pirtle, Sibley/Peteet Design and RBMM, and moved to Seattle to open up his own design firm. It wasn't long before his work attracted the attention of organizations with impressive letters in their names: NBC, the NBA and the NFL.

Today Ken and his creative staff provide a complete scope of graphic design services including corporate collateral, packaging, illustration and especially identities, the firm's forte. Behind every piece of work they do is a strong idea that communicates a clear concept.

"Our solutions are pragmatic," says Ken. His firm is not interested in developing a personal style because "the design must fit each client's individual style, not mine, to be effective."

The firm is accommodating, but that's not why clients seek out Ken Shafer Design. It's the creativity. As Ken explains, "Do great work, and everything else follows."

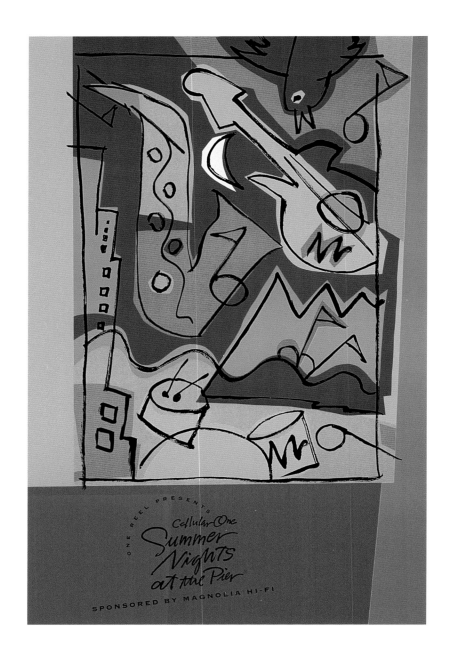

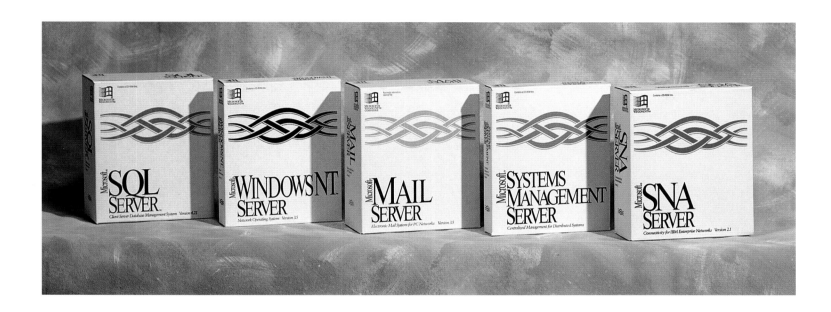

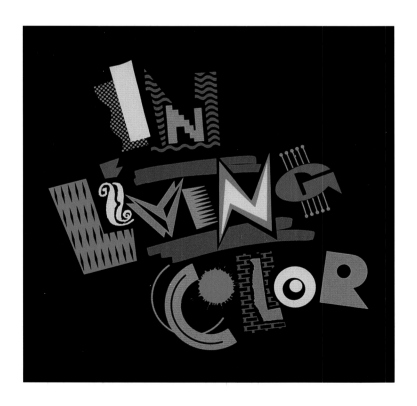

FACING PAGE: Summer Nights at the Pier promotional/commemorative poster for One Reel. Prison Blues pocket flasher for Nordstrom. *Columns* quarterly alumni magazine for the University of Washington.

THIS PAGE: HyperGrafix product logo for Generra. Paradise Grill logo for a tropical burger bar. Crescendo logo for a corporate yacht. Back Office packaging system for Microsoft. *In Living Color* title design for Fox Television.

SPANGLER ASSOCIATES

Kathryn Spangler, a respected business leader in Seattle for 20 years, has a rewarding design philosophy. "Bench-marking is a part of the corporate world," she says. "Design firms should be no different."

Her firm sets specific, measurable performance marks for every project. As she puts it, "Design should give our clients a strategic marketing advantage. Its value should reflect positively on their bottom line."

Spangler's marketing and design teams blend a marketing-driven creative process with a consultative approach to deliver intelligent, compelling print and interactive media solutions. Their elegant, pragmatic approach to the business of design has earned many long-standing client relationships.

The firm's seasoned professionals are experts at building brand imagery. They act with integrity, create with passion, and flourish in partnerships. And they prefer to work with clients who share these same core values. Businesses, they believe, don't do business with businesses—people do business with people.

Small enough to provide personalized service, but experienced enough to handle complex projects, Spangler Associates follows a simple credo: empathize with the client and their audience, have solid objectives, look for unexpected opportunities, have fun.

If you aren't sure about the value of design, you haven't worked with Spangler Associates.

FACING PAGE: Spangler Associates, moving announcement. Howard Johnson & Company, MultiPlan benefits brochure. Farm Credit Services, family of capabilities and product brochures.

THIS PAGE: Artcraft Printing, printing capabilities booklet. Cole & Weber, identity for "Rodeo" in-house electronic production group.

FACING PAGE: The Biltmore Hotel, identity and signage program for a landmark hotel in Los Angeles. Virginia Mason–Group Health Alliance, Alliant Health Plans marketing brochure. Rockwell, 1995 annual report.

THIS PAGE: Grossberg Tyler Lithographers, promotion for new half web press. Ekse Marketing, logo for an advertising, public relations and marketing consulting company. Virginia Mason–Group Health Alliance, logo for a new alliance between two major healthcare providers.

TEAM DESIGN

It's a firm built on the power of collaboration. Powered by multidisciplinary expertise. And fueled by fun.

The name was a logical development of the alliance formed by Diann Bissell, Janet DeDonato and Bob Grindeland in 1988. TeamDesign has always worked according to the belief that relationship building is as important as design skills, that teamwork is the key to success.

In a few short years, TeamDesign has grown to be one of the largest firms in Seattle and one of the most powerful on the West Coast. The firm was one of the first to recognize the potential of digital design technology and today is known for an ability to deliver marketing messages across all platforms: print, interactive multimedia and online communications.

Well respected for their work in the technology and financial industries and for their design of annual reports, TeamDesign is adept at making complex information accessible.

Clients are uniform in their praise: "TeamDesign gives us their best work. They show us new possibilities. And they know how to have fun."

When you work with a team, the whole is always greater than the sum of its parts.

Portfolio photography by David Bell, Studio 3, Inc.

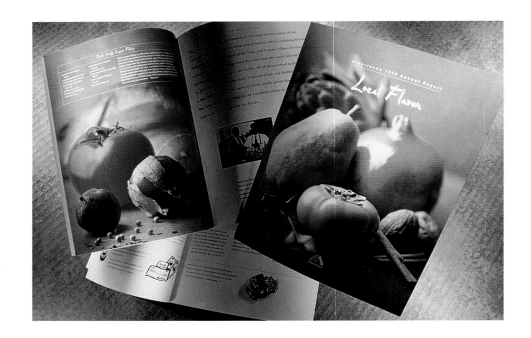

D E L T A

FACING PAGE: Albertson's annual report—the theme of "Local Flavor" included recipes from regions where Albertson's has a significant presence. Montage identity and capabilities system communicates vision, creative expression and computer technology. The Boeing Company employee health benefits system, designed to simplify program choice.

THIS PAGE: Delta Marine identity, part of an image management program positioning Delta as the company that creates Yachts of Distinction. Microsoft's Softimage sales and marketing collateral, targeting professionals who are potential users of this high-end 3-D animation software.

TEAM DESIGN

FACING PAGE: Airborne Express Web site positioning Airborne as a global transportation resource. Microsoft Corporation, InfoSource CD-ROM presenting InfoSource as a tool for finding computing resources worldwide. Oracle Corporation, product identity for use online and in printed collateral promoting Oracle's Server Technologies.

THIS PAGE: Grossberg Tyler Lithographers, CD-ROM— company and designers' perspectives on the continuing merits of printed media in a world of electronic media. !NTERPRISE Networking Services from U S WEST, CD-ROM presentation and training tool promoting Web site hosting services.

THE TRAVER COMPANY

Anne Traver opened her own graphic design firm 20 years ago after graduating from the University of Washington. Since then, she and her team of talented designers have been establishing productive working partnerships with a full spectrum of clients, from arts organizations to computer science companies, from hospitality to health care.

Why do so many consider The Traver Company the right fit? "At seven people, we're a good size," says Anne Traver. "Clients can feel confident with our professional depth while still enjoying personal contact."

The Traver Company arrives at creative solutions both rationally and intuitively— combining an intelligent strategy with the emotive power of design to meet even the most complex communication objectives. They are seasoned professionals who honor their clients, enjoy their work and flourish in an atmosphere of mutual respect. Explains Anne, "We think the rewards of design are found not only in bottom-line returns but also in the enjoyment of day-to-day interaction."

Evidently, business is a pleasure with The Traver Company.

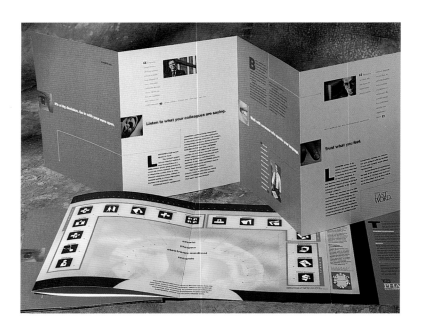

FACING PAGE: Product design and package design for Nordstrom. Accordion-fold catalog for an exhibition of sculpture by Swedish artist Bertil Vallien. Part of a comprehensive system of sales communications collateral for PHAMIS, a health care information systems company.

THIS PAGE: *KKR Review*—a periodical for the executives of KKR companies including Borden, Duracell and Safeway. Identity design for the nation's largest college bookstore.

VAN DYKE COMPANY

"This is an exciting time for designers," says John Van Dyke. "In fact, it's the most exciting time I've ever experienced, with the possible exception of the day I got my first assignment in 1968."

Van Dyke has been around. His personal mission, even in the early days, was to bring national and international corporations to Seattle for design. "I'm proud of this design community," he says, "and proud of my small contribution. Today Seattle is recognized everywhere as the place to get good work."

He is reluctant to talk about himself. "I always put my work in front of me, and let it speak for itself." But he is quick to give credit where it is due. "My clients made the last 20 years rewarding and personally satisfying."

What's in store for Seattle designers? "There are electrifying new possibilities today, and more ways than ever to do good work," he notes. "The people who survive at the top of the design business will be those who think before they do anything. It's not going to be about style. It's going to be about communication. If you're a communicator, it doesn't matter what the medium is—it's the thinking that counts."

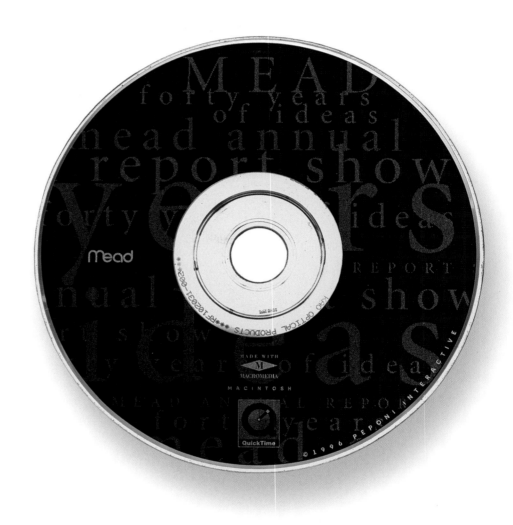

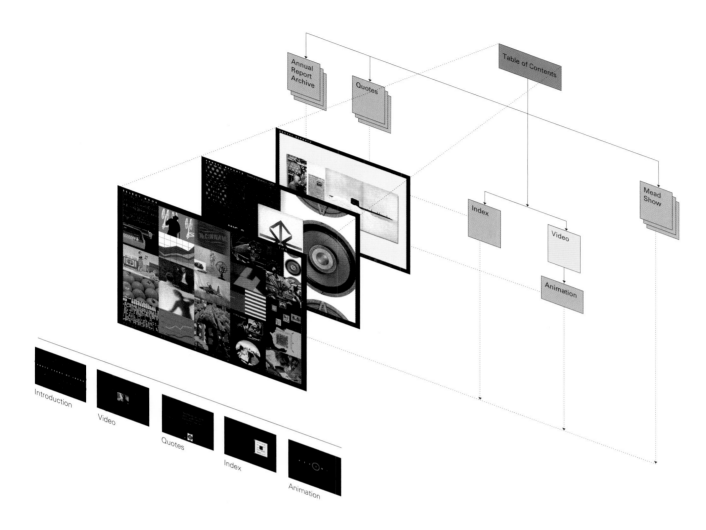

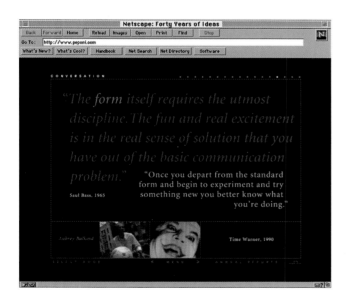

"Forty Years of Ideas," a CD-ROM for Mead Coated Papers created by Peponi Inter-active in collaboration with John Van Dyke. The CD contains a rare collection of 125 award-winning annual reports from 1956 to the present day, along with insightful commentaries from leading designers and thinkers. *Graphis* magazine included the CD in its article on the Mead Show. Over 12,000 CDs went out to subscribers.

WERKHAUS DESIGN

"Businesses employ legal and financial counsel," says Werkhaus principal John Burgess. "We serve as marketing communications *design* counsel."

Seattle locals Burgess and partner James Sundstad are competitive skiers who met on the slopes back in the early eighties. In 1989 they parlayed their mutual passion for art and promotion into a full-service, strategic graphic design firm. Today Werkhaus specializes in brand and corporate identity, package design, and literature systems—developing all the attending components of a company's communications program, including new media.

Werkhaus has named and designed a number of successful brands such as the Alder Cove seafood line and Jet City Ales. What constitutes an effective brand identity? "It must be aesthetically distinct," answers Sundstad, "intelligent, visually compelling, with a clear point-of-difference in the marketplace."

"Design flexibility is our norm," explains Burgess. "Werkhaus doesn't offer clients a 'haus' look. Design should not be mere decoration. Creative solutions must be relevant. They must communicate appropriately."

In 1995, the Werkhaus studio moved to a renovated brick building on Eastlake where the legendary Buffalo Shoes were once manufactured. They kept the old stuffed buffalo head in the entry. Pet the chin when you drop by, it's good luck.

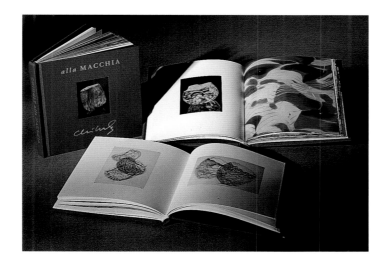

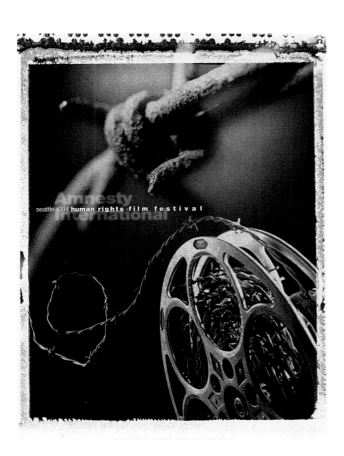

FACING PAGE: Jet City Ale™ brand package design. Alder Cove™ seafood brand package design.

THIS PAGE: Chihuly Studios *alla Macchia* book design. Logic Audio™ software package design system. Weinhard's Red delivery fleet design. Human Rights Film Festival poster design. SUSA™ Spice Blends brand package design.

Z GROUP DESIGN

What do you get when you combine editorial art directors, ad agency executives and talented designers? Answer: The Z Group. And clients get well-rounded communication solutions.

Principals John Zimmerman and Karen Gutowsky met in Chicago when they both worked for *Playboy* magazine. They shared a curiosity about the Pacific Northwest. "We rode a motorcycle cross country and ended up in Seattle on a bright sunny day," says John. "We had to wonder, what is this about all the rain?" Shortly afterward, they arrived to open Z Group Design.

Since 1987 they have been supplying striking and persuasive designs for local and national clients, producing everything from annual reports to point-of-purchase materials, from magazines to exhibit displays.

"We have solid talent and diversified personalities in our studio," says Karen. "We use this diversity and a team effort to spark ideas." Clients are encouraged to get involved in the energy of the creative process since "direct contact with designers is essential."

One visit to the stimulating environment of the Z Group studios in Seattle's Belltown will say more about the term "creative energy" than mere words can describe.

Drop by some day and get out of the rain.

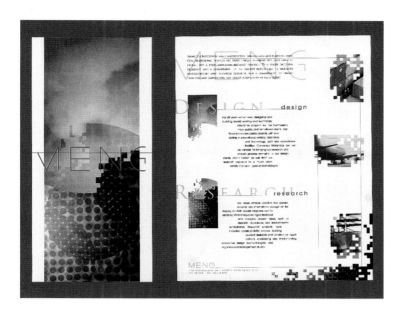

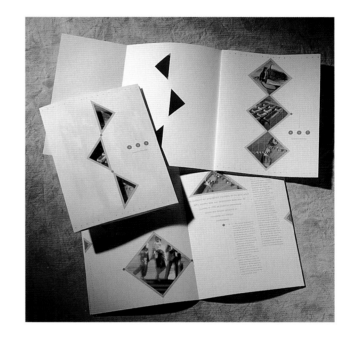

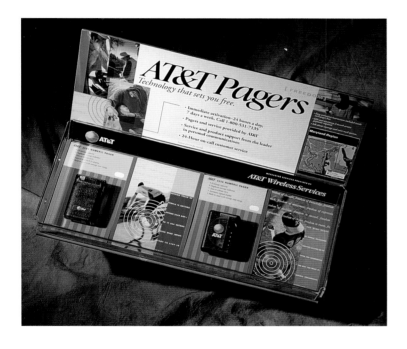

solveris

FACING PAGE: Welcome package for Alaska Airlines "Most Valued Passengers" program, including travel card and benefit overview. Product introduction package for Fluke, including brochure, video and distributor kit. Logotype and mark for Outdoor Adventure River Specialists (O.A.R.S.) .

THIS PAGE: Identity system for MENG, a Seattle-based architect, along with sample page from capabilities package. Annual report for Applied Voice Technology, Inc. (AVT), a computer telephony firm. AT&T Wireless Pagers, point-of-purchase display. Whirligig logo for Seattle Center's yearly children's event. Logotype and mark for Solveris, Inc., an information technology firm.

The test of the artist does not lie in the will with which he goes to work, but in the excellence of the work he produces.

SAINT THOMAS AQUINAS

Artist Representatives

Graphic designers have a love/hate relationship with artist representatives.

Those who love them are busy professionals who appreciate the convenience of seeing many choices, the "no-surprises" negotiating stance and the assurance that they will get exactly what they need, precisely when they want it.

Those who hate them are probably angry that they can't get great work at rock bottom prices by bulldogging individual artists.

In any case, everyone agrees that art reps have brought a certain consistency to an industry where pricing and quality can vary widely.

An art buyer who needs illustrations or photography for high-profile projects such as annual reports usually requires original work. Commissioning such work involves dealing with unknowns. Does the artist or photographer understand what I want? Will they give it to me? Can they do it at a price my client can live with? An artist representative, acting as an intermediary, can make it happen smoothly.

Most Seattle designers have excellent relationships with art reps that have endured over the years. Like writers and printers, art reps play a significant role in making the final design project a success from start to finish.

And what's not to love about that?

KOLEA BAKER
ARTIST REPRESENTATIVE

Kolea concentrates on making work a congenial and gratifying experience for both her artists and their clients. She views herself as a conduit—a transformer—through whom communication passes, is clarified, and is then sent off on the proper path.

She cleverly restricts the number of artists she represents in order to maintain the high caliber of both the service and the work. Each artist is handpicked for their thinking skills as well as their creative talent. Each has a unique conceptual style and a solid professional attitude when it comes to meeting objectives and deadlines.

"I started this business in 1985 because of a love of fine art," says Kolea, "and that passion continues to fuel my work." Both she and her associate, Deanna Camp, are former art directors who bring a firsthand understanding to client interactions. She elaborates: "We've worked on both sides of the desk so we can clearly see both sides of the process."

Kolea arranges the sale and commission of commercial illustration and photography for use in corporate, editorial, advertising and publishing markets nationwide. Her international business is growing steadily, especially in Western Europe where designers value the high technical and creative quality of her American artists.

For people who have only seen her name, it is pronounced Ko-LAY.

FACING PAGE: Jere Smith (client: *Infoworld;* art director: Ben Barbante, *Infoworld*). Don Baker (client: Fidelity Investments; designer: Kathleen Smith, Fidelity Advertising).

THIS PAGE: Brant Day (personal work; designer: Brant Day). Greg Ragland (client: *Current;* designer: Craig McCausland, McCausland Design & Communications, Inc.). George Abe (client: Prudential Mutual Funds; designer: Jerry Tortorella, Prudential Mutual Funds).

THIS PAGE: Hilber Nelson
(client: Prebica Coffee;
designer: Colette Brooks,
Brooks Gruman). Margaret
Chodos Irvine (client: Visiting
Nurse Association of Delaware;
designer: Paul DiCampli, Janet
Hughes & Associates).

FACING PAGE: Tom Collicott (client: *Word Perfect* magazine; art
director: Don Lambson, Word
Perfect Publishing). Jeff Brice
(client: *Wired* magazine; designer: John Plunkett, Wired
Publishing).

PAT HACKETT
ARTIST REPRESENTATIVE

Starting way back in 1979, Pat Hackett almost single-handedly defined the art rep business in Seattle. Her first office in old Belltown had no heat. "I popped a presto log into my stove in the morning and got on the phone doing—you guessed it—cold calls."

Today Pat represents nearly 30 commercial artists—the largest stable in the Pacific Northwest. The group is best known for its diversity. Says Pat, "We have nuts-and-bolts line artists, airbrushers, realists and cartoonists, storyboard and comp artists, photographers, a prop and prototype builder and even a paper sculptor."

Pat serves ad agencies, designers, magazines and filmmakers across the country. She is an accessible, thoroughly professional, extremely efficient businesswoman who, according to clients, "knows how to handle people well."

Although her cold calls are fewer since becoming so well established, Pat still stresses the importance of hard work. "If you're not a little frightened," she says, "it's tough to make it in any business."

It's an attitude that translates into a level of service that keeps clients coming back time and again.

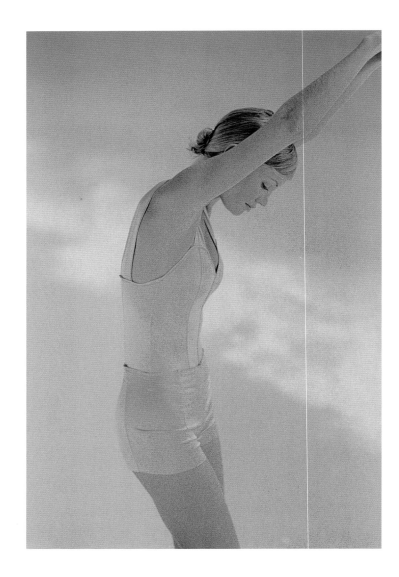

FACING PAGE: Bill Cannon, photograph. Dennis Ochsner, pen-and-ink illustrations for Akasaka Prince Hotel, Tokyo. Bruce Morser, colored pencil illustration for Washington State Apple Commission.

THIS PAGE: David Harto, airbrush and gouache illustration for invitation to Seattle Illustrators Exhibition held by the School of Visual Concepts. Celeste Henriquez, watercolor illustration for children's book *No Dear, Not Here,* published by Sasquatch Books. Kris Wiltse, linoleum block print with color for *Hartford Courant* article about universal tea.

WETLANDS

PRESENTED BY THE WASHINGTON STATE DEPARTMENT OF ECOLOGY WITH FUNDS OBTAINED FROM NOAA UNDER THE COASTAL ZONE MANAGEMENT ACT.

PAT HACKETT
ARTIST REPRESENTATIVE

FACING PAGE: Yutaka Sasaki, digital mixed-media illustration for Chicago's *Global Telephony* magazine. Bill Meyer, ink, watercolor, and colored pencil illustration for Summer Wind real estate development. Kathlyn Shadle, scratchboard and dyes self-promotion. Eldon Doty, computer-generated portrait of Lt. Pinkerton and Madame Butterfly, self-promotion.

THIS PAGE: Larry Duke, scratchboard with color illustration of wetlands environment for Washington State Department of Ecology. Dan McGowan, watercolor and gouache illustration for Celestial Seasonings.

PAT HACKETT
ARTIST REPRESENTATIVE

THIS PAGE: Leo Monahan, paper in dimension, from a series of feather studies. Marco Prozzo, photograph (shot traditionally) for Seattle Symphony's 1994–1995 season brochure (model maker: Mike Wood, 3-D Productions).

FACING PAGE: Ken Barnes, *Four Winds Compass,* sculpted from hand-cut and polished brass, stainless steel and high-relief carved lead glass, 31" x 31" (designed by the artist for Wilsonart). Elizabeth Read, scratchboard and airbrush illustration for children's book *The Cat with a Black Ring,* published by Vantage Press, New York. Bobbi Tull, mixed-media illustration for *Washington Post* article on city gardening. Jonathan Combs, scratchboard with color illustration for cover of 1994 Lands' End holiday catalog.

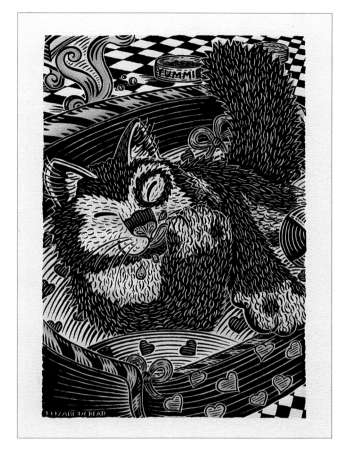

Printed on 110# Eloquence Gloss Book by Potlatch

Directory

KOLEA BAKER
2814 N.W. 72nd Street
Seattle, WA 98117
tel 206/784 1136
fax 206/784 1171
bakerkolea@aol.com

D. BETZ DESIGN
2320 1st Avenue
Suite 300
Seattle, WA 98121
tel 206/728 8804
fax 206/728 8985
betzdesign@aol.com

CORNISH COLLEGE OF THE ARTS
710 E. Roy Street
Seattle, WA 98102
tel 206/323 1400
fax 206/720 1011

DAIGLE DESIGN
5 W. Harrison Street
Seattle, WA 98119
tel 206/282 1299
fax 206/282 1884
daigledesi@aol.com
daigle@daigle.com

EDQUIST DESIGN
3123 Fairview Avenue E.
Seattle, WA 98102
tel 206/328 6010
fax 206/328 6019
edquist@seanet.com

GIORDANO KEARFOTT DESIGN
3605 132nd Avenue S.E.
Suite 310
Bellevue, WA 98006
tel 206/641 5003
fax 206/641 5192
design@gkd.com
resume@gkd.com

TIM GIRVIN DESIGN, INC.
1601 2nd Avenue
5th Floor
Seattle, WA 98101
tel 206/623 7808
fax 206/340 1837
http://www.girvindesign.com

PAT HACKETT
1809 7th Avenue
Suite 1710
Seattle, WA 98101
tel 206/447 1600
fax 206/447 0739
pathackett@aol.com

HANSEN DESIGN COMPANY
1809 7th Avenue
Suite 1709
Seattle, WA 98101
tel 206/467 9959
fax 206/682 3798
hdc@hansendesign.com

HORNALL ANDERSON DESIGN WORKS
1008 Western Avenue
Sixth Floor South
Seattle, WA 98104
tel 206/467 5800
fax 206/467 6411
info@hadw.com

ILIUM ASSOCIATES, INC.
600 108th Avenue N.E.
Suite 660
Bellevue, WA 98004
tel 206/646 6525
fax 206/646 6522
ilium@ilium.com
http://www.ilium.com

IMAGE INK STUDIO
12708 Northup Way
Suite 301
Bellevue, WA 98005
tel 206/885 7696
fax 206/881 0630
imagei@aol.com

LANDOR ASSOCIATES
1411 4th Avenue
Suite 310
Seattle, WA 98101
tel 206/223 0700
fax 206/223 5554
seattle@landor.com

LEIMER CROSS DESIGN CORPORATION
140 Lakeside Avenue
Suite 310
Seattle, WA 98122
tel 206/325 9504
fax 206/329 9891
lcd@lcdannualreports.com

THE LEONHARDT GROUP
1218 3rd Avenue
Suite 620
Seattle, WA 98101
tel 206/624 0551
fax 206/624 0875
donl@tlg.com

NBBJ GRAPHIC DESIGN
111 S. Jackson Street
Seattle, WA 98104
tel 206/223 5555
fax 206/621 2305

PHINNEY/BISCHOFF DESIGN HOUSE
614 Boylston Avenue E.
Seattle, WA 98102
tel 206/322 3484
fax 206/322 3590
lesliep@pbdh.com

KEN SHAFER DESIGN
1000 Lenora Street
Suite 404
Seattle, WA 98121
tel 206/223 7337
fax 206/223 7336

SPANGLER ASSOCIATES
1110 3rd Avenue
Suite 800
Seattle, WA 98101
tel 206/467 8888
fax 206/467 8889
http://www.spangler.com

TEAM DESIGN
1809 7th Avenue
Suite 500
Seattle, WA 98101
tel 206/623 1044
fax 206/625 0154
paular@teamdesign.com

THE TRAVER COMPANY
80 Vine Street
Suite 202
Seattle, WA 98121
tel 206/441 0611
fax 206/728 6016
studio@traver.com

VAN DYKE COMPANY
85 Columbia Street
Seattle, WA 98104
tel 206/621 1235
fax 206/623 5065
vandyk@halcyon.com

WERKHAUS DESIGN
Buffalo Building
1124 Eastlake Avenue E.
Seattle, WA 98109
tel 206/447 7040
fax 206/447 9799
info@werkhaus.com

Z GROUP DESIGN
2121 1st Avenue
Suite 102
Seattle, WA 98121
tel 206/728 2105
fax 206/728 8851
zman@zgrp.com